ACRYLIC

LAURENCE KING

Published by
Laurence King Publishing Ltd
361-373 City Road
London EC1V 1LR
United Kingdom
Tel: +44 20 7841 6900
E-mail: enquiries@laurenceking.com
www.laurenceking.com

A catalog record for this book is available
from the British Library

ISBN: 978-1-78627-570-7

Commissioning Editor: Zara Larcombe
Senior Editor: Katherine Pitt
Design: Mariana Sameiro
Vector line drawings: Akio Morishima

Printed in China

Laurence King Publishing is committed to ethical and
sustainable production. We are proud participants in
The Book Chain Project ® bookchainproject.com

Front cover: Marisa Añón, *Abstract Plants I*, acrylic on paper, 2019

ACRYLIC

Do More Art

Rita Isaac

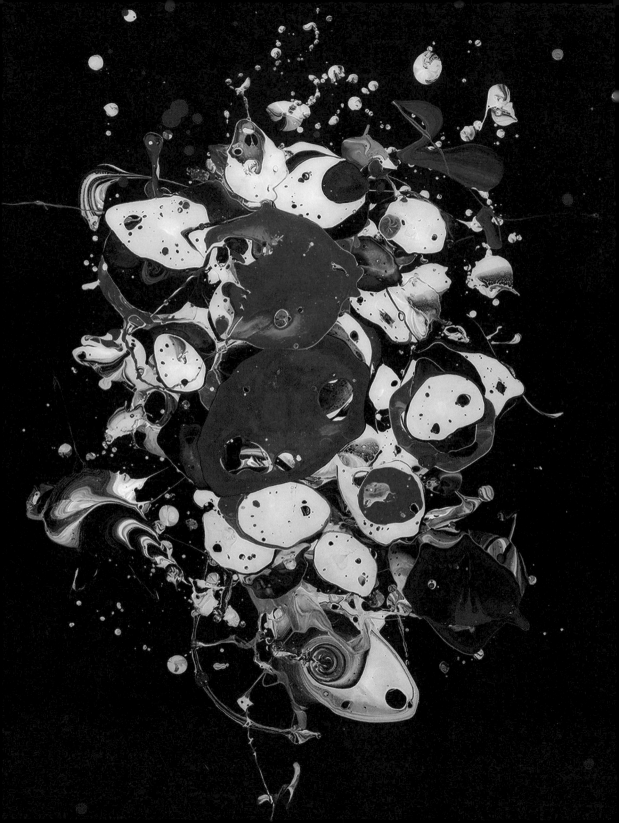

CONTENTS

Opposite: Arthur Brouthers, *Heighten*, acrylic and resin on wood panel, 2016

INTRODUCING ACRYLIC

Compared to more traditional mediums such as watercolor and oil, acrylic is the paint world's new kid on the block. Initially intended for industrial use, this type of paint wasn't sold explicitly for artistic purposes until the 1950s. However, thanks to its bright, saturated colors and its versatility, acrylic quickly made up for lost time, becoming popular with artists such as Andy Warhol, Roy Lichtenstein, and David Hockney.

This popularity is not surprising. Available in many forms, acrylic can be applied in thick, buttery layers reminiscent of oil paint or thinned down to mimic beautiful watercolor washes. It can be poured, pushed, dragged, and splattered on everything from canvas and fabric to metal, wood, and even walls.

If this sounds daunting, fear not—acrylic is also incredibly user-friendly: its fast drying time means you can build subsequent layers more quickly, maintaining momentum in your piece; it is water-soluble while wet, so you can thin it down with water alone and, because it dries to a water-resistant finish, you can paint over it easily, making mistakes fixable.

What's more, there are myriad additives, known as acrylic mediums, that boost its creative potential, allowing you to enhance such qualities as drying time, texture, or pourability, or even create fun effects, such as textured cracks.

Acrylic, then, is an artistic powerhouse, and this book will be your friendly guide to getting the most out of it. Together, we will explore everything from basic skills to the most inventive pouring techniques. All you need to bring is some paint, a brush, and an open mind.

A WHO'S WHO OF ACRYLIC PAINTS

Acrylic paint comes in two different grades: student and artist (also referred to as "starter" and "professional"). They differ both in price and in the pigments used to make them. Student-quality paints, commonly used by beginners, usually combine different pigments or add a "filler" to achieve specific hues, whereas artist-quality paints tend to contain a higher concentration of pure pigment. Mixing too many pigments can result in muddy, dull colors, so for more vibrant, saturated colors it's best to choose from artist-quality ranges.

Acrylic paints are water-soluble, so they can simply be thinned down with water to increase flow and transparency—one of acrylic's main benefits. If you'd like a fluid consistency but a vivid color, it's best to use acrylic ink, fluid acrylic, or any acrylic paint thinned down with a medium such as flow enhancer (see page 12).

Acrylic paint comes in many forms, the most popular of which are outlined opposite. It is, however, also worth considering acrylic markers (see page 74) for more detailed work, or even acrylic spray paints (see page 76) when covering large areas or looking to imbue your work with a street art aesthetic.

The key acrylic paints

Acrylic paints vary in terms of their consistency, or "body." They are all generally intermixable and can be combined with acrylic mediums to broaden the range of possibilities. The following are the most common consistencies:

Acrylic ink
Also known as high-flow acrylic, acrylic ink can be just as brightly colored as other types of acrylic, but with a liquid consistency that's perfect for tinting and staining techniques.

Fluid acrylic
As the name suggests, fluid acrylic paint has a high liquidity, although not to the same degree as acrylic ink. Fluid acrylic has a strong pigmentation and levels out instead of retaining brush marks.

Soft-body acrylic
Soft-body acrylic paint has a medium consistency and is the most commonly found body in beginner-quality paint ranges. It is smooth and easy to spread and mix, retaining some marks but not to the same extent as thicker consistencies.

Heavy-body acrylic
Heavy-body paint has a thick consistency that allows it to retain brush marks and other textures, so it is a great alternative to oils when using the impasto technique (see page 44). You may prefer to use a palette knife to fold and mix heavy-body colors.

A (BRIEF) GUIDE TO COLOR

Regardless of the grade quality of your acrylic paint, it is helpful to understand the character of different pigments so that you can use them to your advantage.

opaque paint

transparent paint

Transparency

Some colors are inherently more opaque than others. If you want to create colored transparencies or glazes, or mix new colors, choose transparent or semi-transparent colors. This will give you clean, bright results. There are different opacity levels in each color spectrum, so bear that in mind when deciding whether to mix a particular paint or use it straight from the tube.

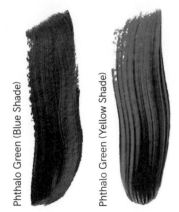

Phthalo Green (Blue Shade)

Phthalo Green (Yellow Shade)

Hue

This term can refer to different things. In color theory, "hue" is commonly used to describe the pure colors of the spectrum—red, blue, yellow, and so on. However, in painting, "hue" is also used to name particular colors in order to indicate their color temperature. For example, Phthalo Green (Blue Shade) is different from Phthalo Green (Yellow Shade): the former is colder, the latter warmer. This is an important distinction when creating glazes or mixing colors.

Some paint manufacturers also use the term "hue" to indicate that a paint has not been created from a single pigment, but instead has been made from a blend of pigments in order to imitate a certain color. This is very common in student ranges.

pure paint

paint diluted with water

Saturation

This describes the intensity of a color. Single-pigment paints are usually more saturated; the color comes across pure and strong. When thinning paint, beware of diluting it too much, as this will affect the color as well as the consistency, causing it to dry dull and faded.

pure turquoise

turquoise tint

turquoise shade

Tonal value

This describes how dark or light a color is. Each hue has its own tonal property. For example, a yellow is lighter than a red or a blue, even if its color is equally saturated and strong. When mixing a lighter version of a color you create what is called a "tint"; a darker version is known as a "shade." A color can be tinted by adding white or another lighter color, while adding a darker color or black will create a shade.

THE WORLD OF ACRYLIC MEDIUMS

Acrylic is a highly versatile paint that allows you to create myriad effects, but you can push your work even further by modifying your paint with additives to enhance such qualities as texture, weight, sheen, drying time, and opacity. Below is an outline of the most commonly used products, which you will also encounter later in this book. Make sure to follow the instructions on any product that you purchase, as mixing ratios and drying times will differ between brands.

In addition to these more familiar mediums, there are many other additives available that create dramatic textural effects, such as Crackle Paste (see page 58) and glass beads medium.

Flow enhancer

Flow enhancer, or improver, is an additive used to thin a paint's consistency in order to improve its flow. Increased flow allows you to create smooth, flat areas of paint without losing color saturation.

gloss medium

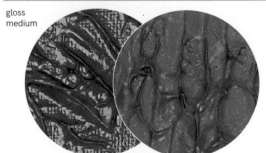

matte medium

Gloss or matte mediums

Gloss or matte mediums alter the sheen of colors and can be used either to enhance or reduce the shimmer of a paint's finish. You can use these mediums as a varnish layer over dry paint, or you can add them to an acrylic color for a thinner, more transparent finish.

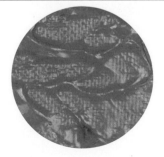

Retarder

A retarder is used to increase the drying time of acrylic paints, giving you more working time, or "open time." This is particularly useful for wet-on-wet techniques (see page 37), achieving soft edges, smooth blending, and mixing.

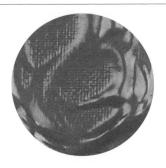

Pouring medium

Very popular for the pouring techniques used to create fluid art (see page 103), this acrylic polymer increases the fluidity of a paint and gives it a self-leveling quality without adding transparency. It creates a smooth, even surface of opaque color.

Soft, regular, and heavy gel

soft-body gel

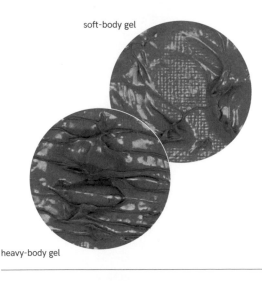

heavy-body gel

Viscous and pourable, gels are a great way to extend paint and alter consistency. There are typically three densities of gel available: soft, regular, and heavy. Soft-body gel holds small peaks and textures, while heavy-body gel allows you to build thick three-dimensional textures. Regular-body gel sits between these two in terms of solidity.

These gels can also be added simply to extend your colors, allowing you to use less paint while retaining color saturation.

The majority of gels are available in three different sheens (gloss, matte, and semi-gloss), enabling even finishes prior to varnishing your work. Gloss-finish mediums are better for transparent glazes, whereas matte-finish mediums enhance a color's opacity.

Clear tar gel

Clear tar gel, as the name suggests, has a very thick, tarlike consistency. It can be used to increase transparency and sheen, while also leveling out brush marks and other textures. (If leveling out brush marks is very important to you, try self-leveling gel, which is even more effective.) Clear tar gel retains color and dries into a transparent, flexible film. It can be mixed with fluid paints for marbling techniques (see page 114) or used as a binder in collage work (page 62).

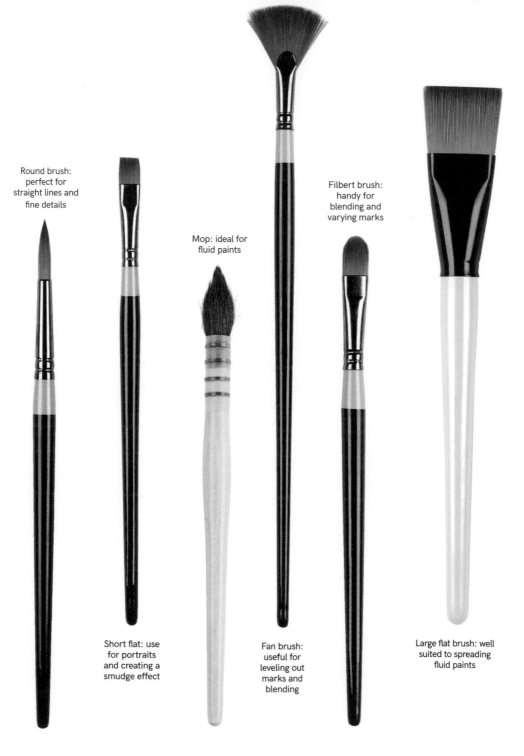

Round brush:
perfect for
straight lines and
fine details

Short flat: use
for portraits
and creating a
smudge effect

Mop: ideal for
fluid paints

Fan brush:
useful for
leveling out
marks and
blending

Filbert brush:
handy for
blending and
varying marks

Large flat brush: well
suited to spreading
fluid paints

GET TO KNOW YOUR BRUSHES

With acrylic paint, the right brush will enable you to create the exact marks you want, whether fluid, bold, delicate, or precise. Brushes made from soft natural hairs, such as squirrel, sable, and rabbit, are traditionally used with watercolor. They are also ideally suited to fluid acrylic paints as they readily soak up large amounts of water, dragging paint for longer.

Hog-bristle brushes are much firmer, and sturdy enough to push thick consistencies, making them a popular choice for use with impasto and when creating textured finishes.

Synthetic brushes are often best suited to acrylic paint as they are more resistant and springy than natural bristles. There are plenty of synthetic brushes available, from soft and flexible brushes that drag fluid consistencies, blend evenly and leave smooth surfaces, to springy and stiff brushes that can push heavy-body paint and leave visible textures.

When selecting your brush, it's also important to take into account handle length. Short handles are better for painting details that require precision, especially when working close to your surface, whereas long handles are usually better for creating larger artworks.

palette knife

foam roller

Other useful tools
Although brushes allow you to create a variety of different effects, to get the most out of your acrylic paint it's important to consider other tools, too, such as palette knives and foam rollers, which we will explore later on.

Another key tool for an acrylic painter is a palette. This is a non-absorbent tray on which you can arrange and mix your paints while working. You can even buy stay-wet palettes, designed specifically to help keep your paints wet—useful for combatting acrylic's rapid drying time.

palette

PAINTING ON PAPER

Acrylic can be applied to a plethora of different materials—try painting on wood, fabric, leather, even the walls... Having said that, the most crucial surfaces for most artists are paper and canvas (see page 18).

Easily transportable and relatively cost-effective, paper is a wonderful surface to use if you are trying your hand at different techniques. While there are many papers on the market that can be used with acrylic, the most suitable are watercolor paper and acrylic paper, the latter having been developed specifically to hold acrylic paint.

When choosing paper, it's important to consider both texture and weight. How rough or smooth the surface of the paper is will determine whether your brushstrokes are grainy or sinuous, or somewhere in between. As a rule, "hot-pressed" paper is the smoothest, while "rough" is the most textured. A paper's weight will determine how much liquid it will withstand. When working with acrylic, 90lb and 140lb are the standard weights, but you can also buy much thicker papers. The heavier the paper, the more liquid it will hold; papers with 140lb or more will receive soft-body acrylics and even fluid inks with little warping.

To increase a paper's absorbency and even out its surface, you can prepare it as you would a canvas by applying a primer, or ground (see page 20). Bear in mind, though, that this will reduce the effect of bleeding if you're applying thinned washes.

Another great option for acrylic artists is canvas paper. This medium-weight paper mimics the lovely texture of canvas and has a coating that provides a great grip for acrylic, preventing the paint from sinking or bleeding. Canvas paper generally comes in user-friendly flat sheets, bound together in a pad.

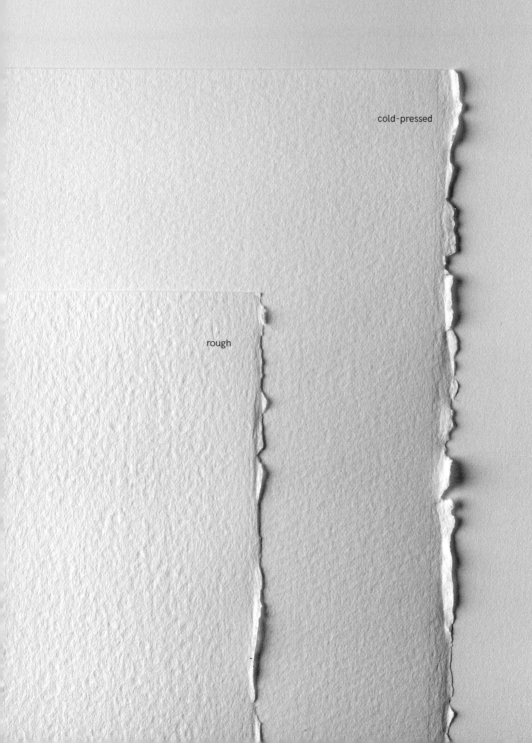

hot-pressed

cold-pressed

rough

PAINTING ON CANVAS

Canvas is arguably the surface most associated with all forms of painting, yet canvas and acrylic are particularly well matched because, unlike oil paint, acrylic is less likely to crack when the canvas moves.

You can apply acrylic to either cotton or linen canvas. Cotton is the most cost-effective variety, while linen is known for its strength and durability, making it better suited to paintings requiring lots of paint or rougher techniques, such as impasto. Linen also retains more of its natural oils, so it will stay flexible longer than cotton canvases, which can become brittle over time.

A fine canvas has the smoothest texture, which is great for portrait painting or delicate compositions, while a rough canvas has a pronounced weave that will add more texture to a painting.

A canvas's weight is determined by the thickness of the thread and how tightly it is woven. The heavier the canvas, the more tension it can take without tearing. So it's better to choose a heavy canvas for large compositions, or those that will be required to hold a lot of paint.

Before you work on your canvas, it's important to stretch it. At the beginning, you'll probably find it easiest to use prestretched canvases.

unprimed raw cotton

cotton primed with gesso

linen primed with a clear primer

PREPARE AND PRIME YOUR CANVAS

A primer is a ground, or undercoat, that gives your canvas—or whatever surface you're working on—enough absorbency and grip to receive paint and mediums, while also retaining a certain malleability and movement. Acrylic paint can be applied with no priming at all, but for better, more durable results it's best to prepare and prime your surface beforehand, depending on the effect you want to achieve.

When applying acrylic paint to a porous surface such as canvas or paper, choose a primer that will retain absorbency, prevent the pigment from sinking, and stop the paint from bleeding through or drying patchily.

You should apply the first layer of primer in one direction, dragging it from one side to the other, until the whole surface is covered evenly, and then, once this first layer is dry, apply the second layer in the opposite direction. Repeat this process until the support is thoroughly and evenly covered—three times is usually enough. Please note that several thin layers are preferable to fewer thick ones.

Acrylic gesso
The most common primer for acrylic paint is acrylic gesso, as it is easily applied to the most common paint surfaces: canvases (either cotton or linen), boards, and paper. Acrylic gesso is composed of acrylic polymer and chalk. The acrylic polymer gives the surface pliability and elasticity, while the chalk provides absorbency.

Clear primer
Another popular choice is a clear primer. This looks white while wet but dries clear, allowing the natural color and texture of your surface to show through.

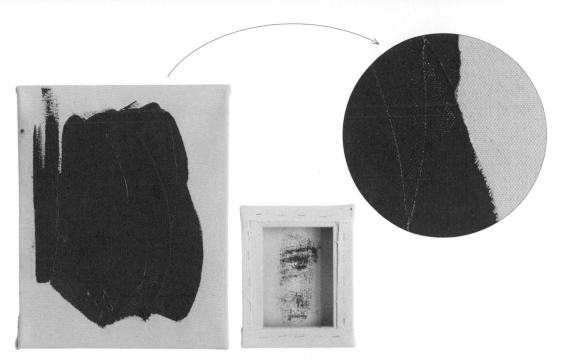

acrylic painted on unprimed canvas

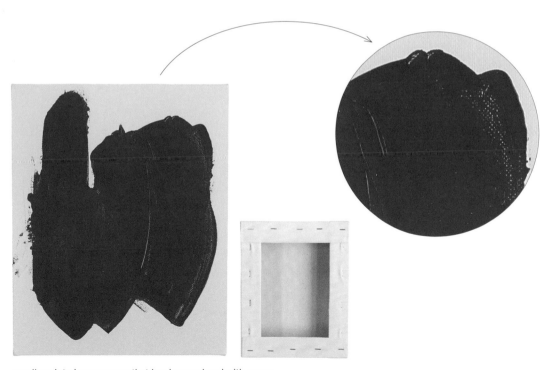

acrylic painted on a canvas that has been primed with gesso

UNDERSTANDING UNDERPAINTING

Underpainting typically refers to a monochromatic first layer of paint with which you can sketch out the composition and map out the image's tonal scale, blocking in areas of light and shadow before layers of color are added. Traditionally an oil painting technique, an underpainting can make an acrylic painter's life easier, too. Here are two useful underpainting techniques:

Tonal underpainting

If you wish to create natural tonal transitions, like those used in landscapes, for instance, tonal underpainting works best. Darker tones are frequently used as base colors—particularly burnt earthy tones, dark greens, and blues or grays. Take whichever color you choose and thin it by adding increasing amounts of water to create lighter tones, using the white of the canvas as the lightest tone. Using tone to describe the subtle transitions from light to dark can help build the illusion of form and volume in your work.

1

2

3

Single-tone background

For works with dramatic contrasts, use a single-tone background by applying a base color evenly over the surface. Choose a dark opaque hue that contrasts with the others in your composition. This will give clear definition to the shapes and volumes created in subsequent layers, making it easier to define light and dark values. Single-tone backgrounds are useful when painting portraits in which a figure in the foreground is kept distinct from the background.

1

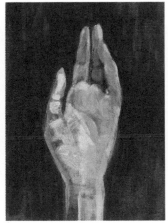

2

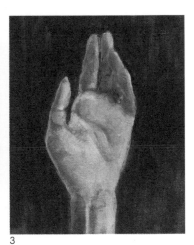

3

A FEW TECH-NIQUES

CREATE TEXTURE WITH DRY BRUSHING

Opposite: Jean Smith, *Singer #4*, acrylic on canvas panel, 2017

Dry brushing is a technique that involves applying a very small amount of paint to a dry brush and dragging it across your canvas to create textured, scratchy, or hazy effects, such as those used by Jean Smith to create the portrait opposite. You do not wet the brush before picking up paint; instead, you pick up a small quantity of paint on the brush, then dab it on a palette to remove any excess before applying it to your surface.

The thicker the paint, the easier it is to achieve textured marks. The surface you are painting on will also affect the results: the texture of a cotton canvas will give more pronounced marks, while a smoother surface will allow the paint to glide, providing smoother coverage.

You can apply more pressure with stiffer bristles (e.g. hog) or a synthetic brush with a good bounce (stiff, springy bristles), so when you choose your brush, opt for one that will allow you to make your desired range of marks.

TRY IT YOURSELF

1. Using a flat brush with short bristles, apply some heavy-body paint with a dabbing motion, spending more time on areas where you want a darker color.

2. Use a fan brush to create a more textured impression.

3. Apply the paint with an angled shader brush to create angular marks.

4. Create subtle tonal or color transitions by applying different paints next to each other and then dabbing the edges to push the colors together until they overlap slightly.

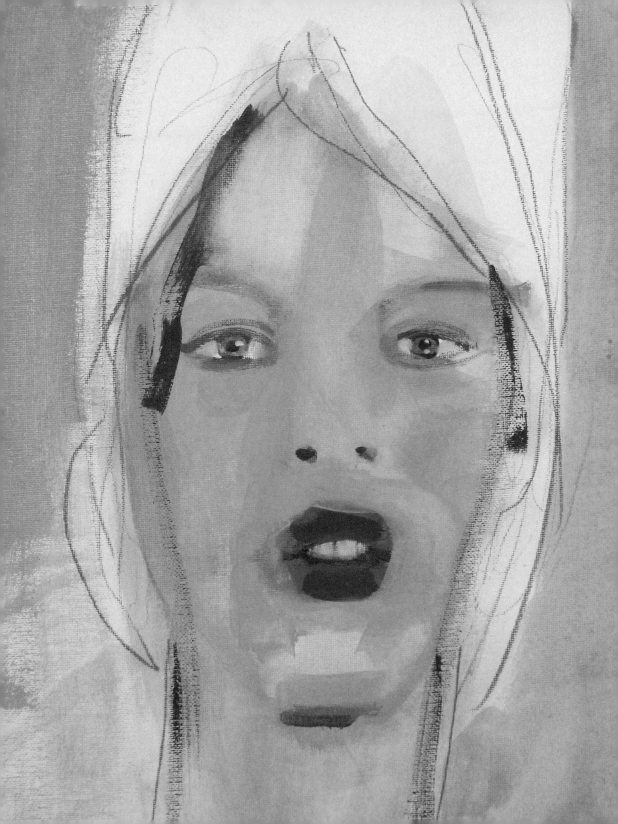

PRODUCE BOLD, FLAT COLOR

Opposite:
Dominic Joyce,
Neon Duplex,
acrylic on
canvas, 2013

Acrylic paint dries quickly and, once dry, it doesn't blend with other colors, resulting in opaque and vibrant layers. This makes it a great medium to use if you want your work to have a flat, graphic look. For the best results, the choice of surface is really important: the smoother the surface, the easier it will be to achieve an even finish.

When choosing your paint, opt for soft-body acrylic varieties with a fluid consistency that will cover your surface evenly and leave no brush marks. You can enhance this by adding a flow improver to the water you use to thin the paint. Soft and flat synthetic brushes are ideal for this technique as they won't leave any streaks, ensuring a completely flat and smooth finish.

If you want to create sharp, clearly delineated sections of color, like those in Dominic Joyce's Pop art-flavored work opposite, you can use masking tape to define certain areas before applying paint. Let the paint dry before removing the tape and moving to the next section.

CONVEY DEPTH WITH FLAT ART

You can create the illusion of space and depth with flat art by simplifying an image into successive areas of flat color. Several small patches of different tones, when combined, will suggest a natural gradation.

For instance, the vibrant figurative painting shown opposite, by the artist Joanna Dziedzianowicz, uses perspective and color to enhance the illusion of depth. In the example on page 28 we saw how saturated colors can be applied in flat and opaque layers that don't overlap at all. Here, Dziedzianowicz has applied the paint in smaller sections, overlapping it ever so slightly to create softer edges. This creates the impression of depth as the contours are more subtle, producing more natural-looking forms. Dziedzianowicz has also employed different hues and color temperatures to convey distance, using the most saturated colors for the figures in the foreground, and more muted tones for the background.

Please note that soft-body acrylics work best with this technique, because they spread more evenly.

TRY IT YOURSELF

1. Apply soft-body acrylic paint in sections of flat color (i.e. with no gradation), thinning the paint at the edges where colors will overlap.

2. Using a slightly lighter shade, place another section of paint next to your first. Once this has dried, apply a semi-translucent wash over the top, to start building depth and the impression of light reflection.

3. Add the darker shade again, so that the lighter one is sandwiched between the two. Once dry, apply an even more translucent wash over the top. Notice how the lighter section is brought into the foreground while the darker tones recede to the background.

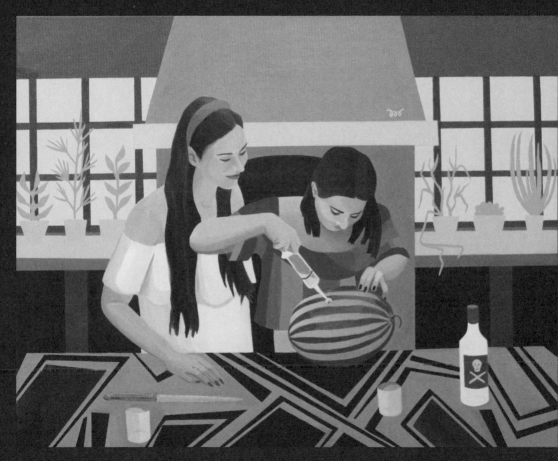

Joanna Maria Dziedzianowicz, *Wifeys Home Alone*, acrylic on canvas, 2018

ADD DEFINITION WITH HARD EDGES

The outlines of painted shapes are commonly described as having hard or soft edges. Hard edges are created using crisp, sharp lines that make a shape stand out in a composition, bringing it into the foreground. Great for creating geometric shapes, this technique was frequently used by abstract painters at the turn of the nineteenth century who favored clean-edged color over more expressive marks.

An easy way to achieve hard edges is to seal paint sections with masking tape (ideally acid-free). Apply the tape only after the surface has been properly primed (see page 20) and left to dry thoroughly.

When selecting your paint, any consistency will do. However, soft-body acrylic paint should be combined with Golden's GAC 200, a fluid medium that will harden the paint while it's drying, giving it a sharper finish. Use a soft synthetic brush to achieve a completely flat finish, free of brush marks.

1. Apply a layer of primer or a base layer of paint to your canvas. Once this initial layer is completely dry, apply the tape, pressing down on it with your fingers or gently rubbing it with a soft cloth to ensure that it has stuck to the surface properly and no paint can seep through underneath it.

2. Apply paint to the masked areas, using a soft brush for a smooth finish, or a brush with harder bristles if you would like more texture.

3. Remove the masking tape once the paint is thoroughly dry, then move to the next section.

NOW SOFTEN YOUR EDGES

Opposite:
Sherry Loehr,
Dusk, acrylic
on panel, 2018

When painting figurative compositions, soft, blurry edges can be used to convey distance—background shapes tend to look less focused than those in the foreground—or to direct the viewer's attention to a particular element of your painting, just like adjusting a camera's focus when taking a photograph. In *Dusk*, for instance, Sherry Loehr has used a crisp line to evoke water lapping at the shore in the foreground, but has used a softer line to represent the hazy horizon in the distance.

It can be difficult to soften edges when using acrylic, because it dries so quickly, but it's not impossible. The wet-on-wet technique (see page 37) will allow you to soften the edges as you go, or you can soften the edges of a painting after it is dry. The trick is to use your acrylic (any type will do) more opaquely where you want definite color, and dilute it with a matte medium or wetting agent in areas where your paint transitions into a different color.

Choose the brush stiffness according to the surface you're using. Soft synthetic brushes are better suited to smooth surfaces, but for a textured weave, use hog or sturdy synthetic bristles.

TRY IT YOURSELF

1. Paint your composition on your canvas and define the different areas of color.

2. Once this is dry, mix a small amount of matte medium with your paint, then lift a small amount of it with an almost-dry filbert brush and apply it in small circular motions over the line of any edges you wish to soften.

3. You can also use a fan brush in a feathering motion to further soften the edges and create a smooth transition between colors.

hard edge

softened edge

SEAMLESS BLENDING— THE "WET-ON-WET" TECHNIQUE

Opposite: Glen Rubsamen, *None of My Business*, acrylic on panel, 2015

When painting with acrylic, there are times when you will want to mix two colors in a seamless transition. One way of achieving this is by using the wet-on-wet technique—blending colors while they're still wet. The biggest challenge here is the quick drying time of acrylic paint, so it's best to use slow-drying acrylic, or to add a retarder to your paint to increase the drying time (see page 12).

Soft synthetic brushes will also help you produce a smooth transition, as they leave no obvious brush marks, and the smoother your surface, the quicker and easier it will be to achieve a seamless blend. You can either prime and sand your canvas or, preferably, buy a sturdy gesso board, finely sanded to a seamless finish.

TRY IT YOURSELF

1. Make the canvas slightly damp, with either a brush or a sponge. Apply the first layer of color, then place the second color next to it, making sure to leave a space between the two. Use as little paint as possible—this will enable the two colors to merge more easily.

2. Unite the two colors by blending them toward each other using a zigzag motion. Keep your brushstrokes parallel for a smoother gradient. If any excess paint is blurring the transition, wipe your brush clean with a damp cloth and then continue the blending motion until no color disparity or brush marks remain.

MIMIC A WATERCOLOR EFFECT

Opposite: Elise Morris, *Spring Spell 3*, acrylic and graphite on paper, 2015

As we will see, it is possible to thin down acrylic paint to reduce its opacity without sacrificing color vibrancy (see page 51). You can use the same thinning process to achieve a completely different effect known as "staining," in which very fluid paint infiltrates and bleeds into porous surfaces, such as unprimed fabric or paper. The effect is beautiful, resembling delicate watercolor washes.

The final result will vary depending on the consistency of the paint you use and the surface on which you're painting. As a rule, paper will absorb more paint, enhancing the bleeding effect, while unprimed canvas, which is less absorbent, will give you sharper edges.

To create the work opposite, Elise Morris combined acrylic paint and graphite on highly absorbent paper to create delicate, almost transparent flowers.

TRY IT YOURSELF

1. Using a clean soft brush, apply water to the areas where you want to add color, then release drops of fluid acrylic paint onto the damp page, letting them flow freely into lightly colored washes.

2. While the first layer is still wet, apply drops of another color, allowing them to blend and bleed into each other.

3. Once the first layers are dry, you can add further washes of fluid acrylic to create different layers. Try adding more saturated colors to create contrast and impact.

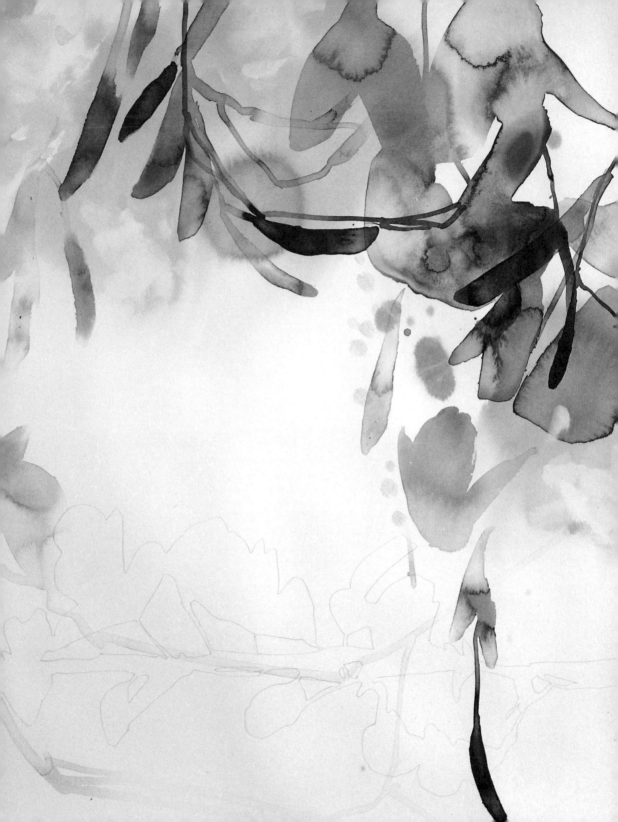

SPLATTER, FLICK, AND BLEED

We have discovered how to form watercolor-like washes with acrylic paint (see page 38). Now we will explore the more expressive and gestural techniques of splattering, flicking, and bleeding using acrylic ink. These provide a lovely way to create movement and pattern in your work.

Pick a surface with an even absorbency, such as watercolor paper, Bristol board, or clayboard. This will allow the ink to dry on the surface, creating really sharp and defined outlines, while retaining maximum vibrancy. However, different papers and saturation levels will alter the effect, so don't be afraid to experiment.

Opposite: Acrylic ink bleeds into 140lb watercolor paper, forming an abstract flower.

TRY IT YOURSELF

Splatter
Pick up some ink with a pipette and press it onto the paper, releasing the color. Try repeating this at different distances from the paper and combining different colors, creating a random, expressive pattern.

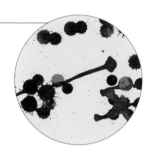

Flick
Hold a soft, round synthetic brush laden with acrylic ink or fluid paint above your paper, then snap the paintbrush toward the paper. You can then wait for the colors to dry before adding further layers, or you can continue adding ink while they are still wet, which will allow the inks to combine freely.

Bleed
With a large brush, apply a wash of clean water before adding the ink. This will allow your colors to flow and bleed.

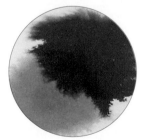

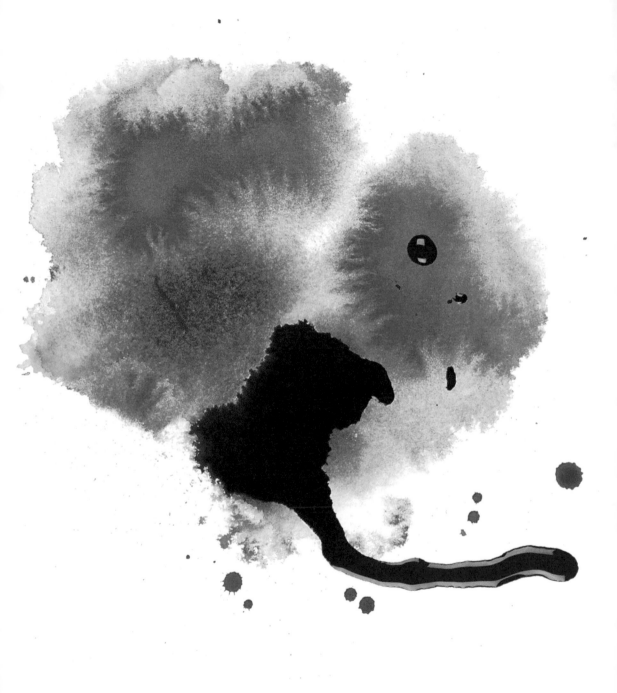

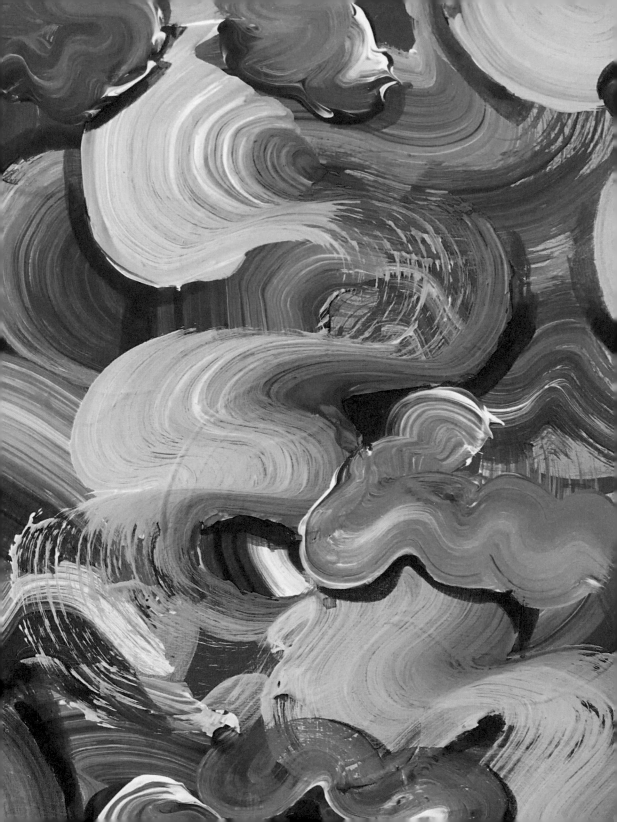

DRAG PAINT TO CAPTURE MOVEMENT

Opposite:
Dan Huston,
The Sun on My Neck (detail; left), acrylic on wood panel, 2017

One of the best things about heavy-body acrylic paint is its thick consistency—it can be used to preserve brush marks and create texture without the colors blending. Dragging dense paint across a surface is a great way to form beautifully sinuous lines, resulting in expressive, textured paintings with vibrant colors, full of energy and movement.

To make your paint even thicker, try mixing acrylic colors with a heavy-body gel that will add density without sacrificing color saturation (see page 13).

TRY IT YOURSELF

1. Select a few heavy-body acrylic paints in different colors, and place hazelnut-sized amounts of each color side by side in a line on your canvas.

2. Using a flat brush that's wide enough to reach all the paint and with enough bounce to ensure that the paint is manipulated easily, pull the paint downward, moving from side to side as you make your way down the surface. Make sure to retain contact with the surface while you drag the paint, as this will prevent the colors from blending.

3. If, however, you'd like the colors to blend together slightly, repeat the dragging action while the paint is still wet, using a clean brush. It's important not to use the same brush, as this will mix the colors completely, diminishing the effect.

BUILD TEXTURE WITH IMPASTO

Opposite: Paul Norwood, *Beach Read*, acrylic on canvas, 2018

Impasto is a longstanding painting technique in which artists apply paint in thick layers to create rich textures. While traditionally used with oil paint, this technique can be employed just as effectively with acrylics, as Paul Norwood's vibrant beach scene opposite demonstrates. In fact, acrylic paint provides two distinct advantages: a shorter drying time and much less risk of cracking or warping while it dries.

Choose heavy-body acrylics for this method, as these are almost as thick as oil paint. You can also add a heavy-body gel (see page 13) to your paints to enhance their consistency, ensuring they hold every peak and mark, almost as if you had molded them. Using thick, stiff brushes to push the paint around larger areas will also add a three-dimensional element to your work.

Impasto is a highly tactile and intuitive technique that produces very expressive results with ease. For figurative images, however, sketch out the different areas of color or tone on your canvas first, to free yourself from worrying so much about proportions and depth.

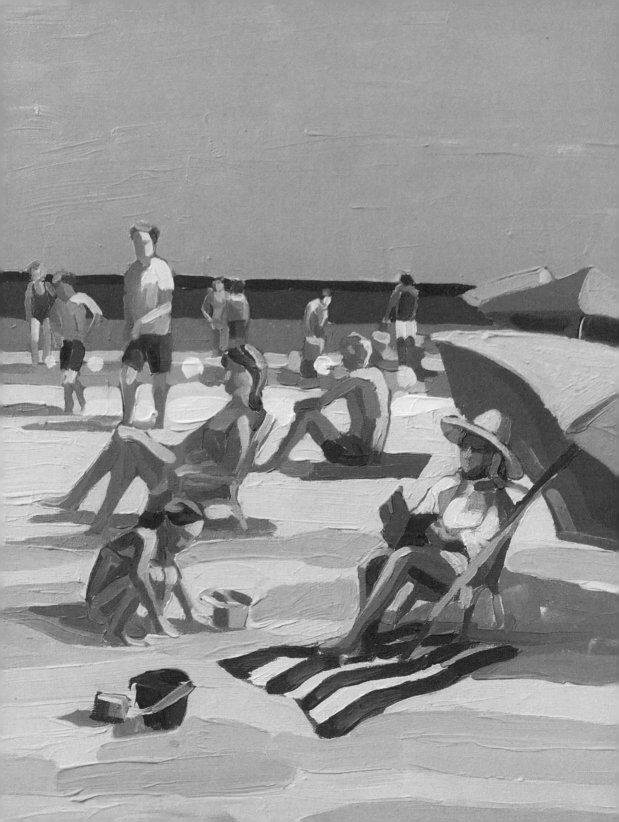

TRY IMPASTO WITH A PALETTE KNIFE

Opposite: Dan Henderson, *Hattie's Lobster*, acrylic on Bristol paper, 2017

Acrylic paint is often applied with a brush, but why not use a palette knife to switch things up and create different effects? A palette knife can be used to form layers of impasto (see page 44), for instance, when the paint is thick enough. To achieve a textured composition like Dan Henderson's opposite, it is easier to work with a paint that has a thick consistency—a heavy-body acrylic, ideally, or an acrylic thickened with heavy-body gel.

Once your chosen surface has been prepared—wood works particularly well for this technique (see page 84)—you can apply the paint directly with the knife. Do not overwork the paint, as this will blend the colors into fewer shades; instead, fold, press, and push the paint with swift movements to produce bold, dynamic strokes.

Palette knives come in many different sizes, so select one that best fits the scale of your artwork.

TRY IT YOURSELF

Make an impression
Make marks by pushing your palette knife into the paint, either holding it flat against the support or pressing it on its side.

Marble
Create a marbled effect without blending the colors completely by dragging sections of paint over each other in a flicking motion, but without pressing the palette knife down.

Fold, press, and push
Fold, press, and push the paint if you want to combine colors loosely and retain a sense of movement in your work.

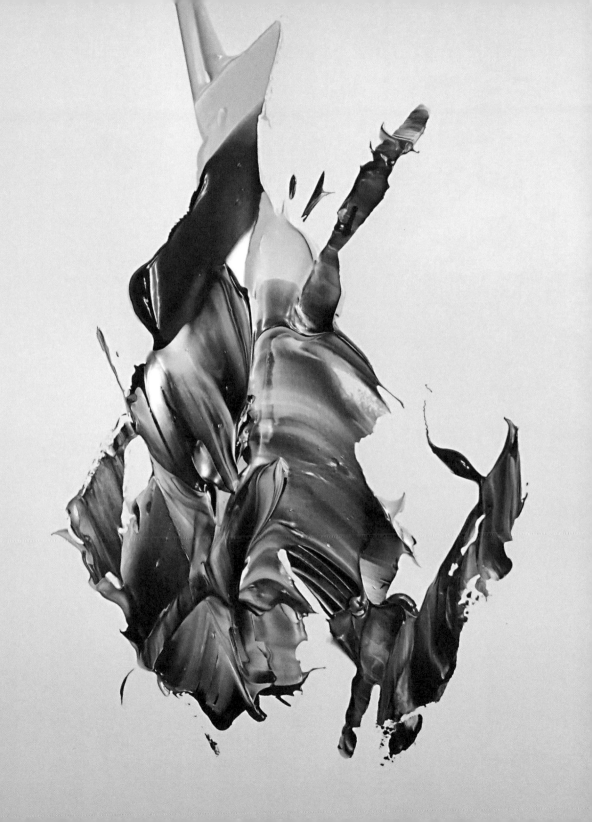

SCRATCH THE SURFACE WITH SGRAFFITO

Sgraffito is a technique that involves scratching through a layer of wet paint to reveal what lies beneath. It can be used figuratively to indicate details in plants and leaves, for example, as Kathryn Macnaughton has done in the work opposite, or more abstractly to add expression and movement—proving that removing paint can be as effective a technique as adding it.

Sgraffito can be achieved with either soft- or heavy-body acrylic paint and any tool that will scratch the surface, from a drypoint needle or the end of a paintbrush to a fork!

TRY IT YOURSELF

Apply one or several layers to form your background. Once this is dry, apply a topcoat of paint and, before it dries, start working on it with your chosen scratching tool.

Cross-hatch
Use a drypoint needle to make lots of thin marks running in parallel lines, and then cross over them with lines running at a right angle. A technique commonly used in engraving and etching, cross-hatching is a highly effective way to create shade and volume.

Scrape the entire surface
Scrape the top layer of paint using a large utensil, such as a palette knife, until only a thin veil of color remains.

Drag and lift the paint
Drag a watercolor pencil, water-soluble graphite, or charcoal across the wet paint to lift part of it. These utensils will also partially dissolve, leaving darker marks around the scratch marks.

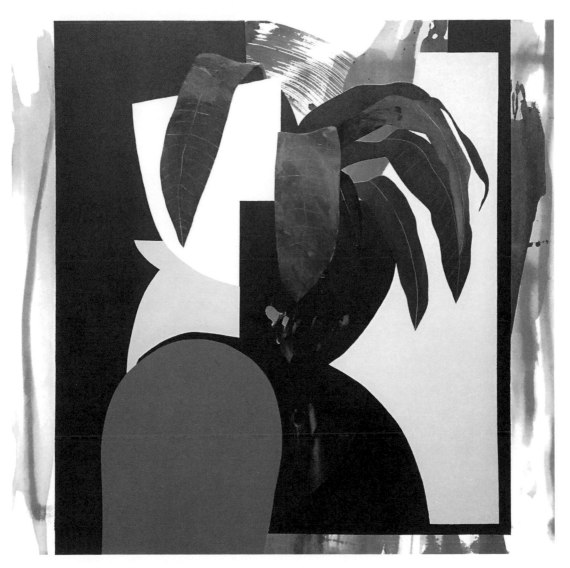

Kathryn Macnaughton, *Bounty Hunter*, acrylic and spray paint on canvas, 2017

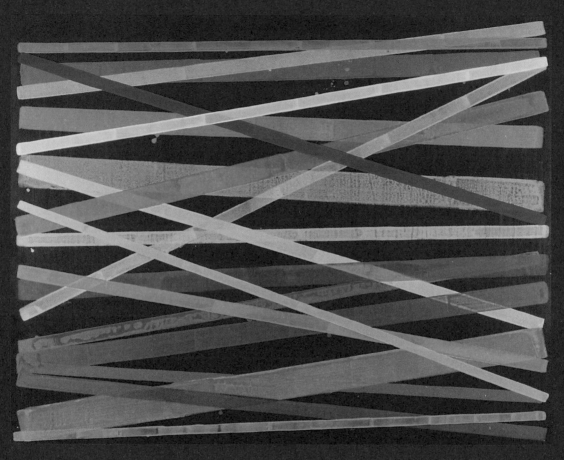

Marta Marcé, *Mikado 21*, acrylic on canvas, 2007

PLAY WITH TRANSPARENT LAYERS

While acrylic paint is generally considered to be more opaque than watercolor, with the right technique it is still possible to create luminous, translucent veils of color. Here, for instance, the artist Marta Marcé has used transparent layers to create a work that's full of energy and vibrant color.

You can either purchase a transparent variety of acrylic ink (see page 9) or thin down any acrylic paint with an acrylic flow releaser or airbrush medium, which, unlike water, will increase fluidity without making the color any less vivid. Just be sure not to overdilute your paint; you want a transparent glaze with a fluid yet consistent body, not a completely liquid wash.

Choosing the right surface is also important for this technique. It's easier to apply fluid washes of acrylic onto raw cotton canvas than onto primed linen, which is resistant to water.

TRY IT YOURSELF

Create defined lines
Using a soft brush and a quick, light touch, apply a stroke of one color, wait for it to dry and then apply the next.

Blur the edges
Alternatively, apply the next layer of paint while the first is still wet, allowing the edges to blur.

Add texture
If you would like to add texture in certain areas, tint some soft-body gel with a small amount of paint and apply it using a brush with stiffer bristles. This will also help prevent the colors from blending.

CREATE DEPTH WITH PATTERNS

Combining different mark-making techniques in the same work is a highly effective way to add depth and interest. By applying acrylic with brushes, sponges, cotton swabs, fabrics, rollers, nets, and so on, you can create all kinds of shapes and textures that will draw the eye to different areas of your composition.

Using different consistencies of acrylic paint will facilitate an even wider range of marks, from hazy patterns that resemble dry brushing, to drips made with fluid acrylic, such as those representing trees in the work below. You can also contrast solid opaque color patterns with more transparent shapes—the pattern world is your oyster!

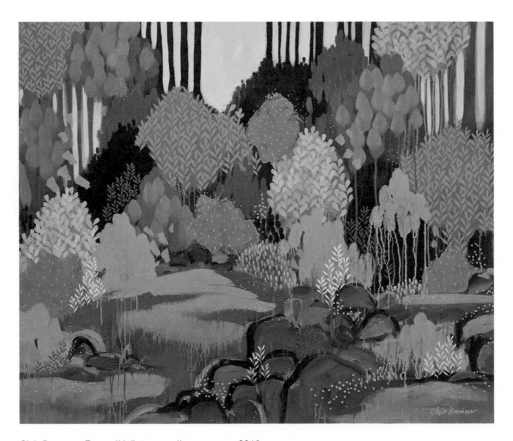

Clair Bremner, *Farewell Winter*, acrylic on canvas, 2018

1. Create a background by applying a solid layer of even color to your surface.

2. Once this layer is dry, select any acrylic paint and apply blocks of opaque color with a sponge or roller. You can repeat this across several areas of your surface to create patterns.

3. Use different utensils to leave different marks. Make sure to experiment with varying degrees of opacity and transparency (see page 54). You can also repeat a print without adding more paint, to leave a fainter mark.

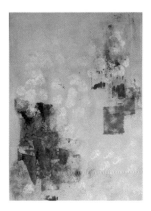

4. Allow the paint to dry and then repeat this process over different layers, allowing some impressions to overlap or replace others, building the illusion of depth. This will result in a succession of veils and layers that interact nicely.

MAKE A GLAZE

A glaze is a thin top layer of translucent color that allows whatever is underneath to show through. This technique is a useful way to add warmth, bring certain objects or figures into the foreground (matte figures or objects will recede into the background), and create subtle transitions between colors for greater realism. Acrylic is particularly well suited to this technique because it dries much faster than oil paint.

By mixing any acrylic paint with a gloss medium, you can glaze the whole surface of a painting to alter its color subtly, or you can build up layers of transparent color during the painting process.

TRY IT YOURSELF

1. Start with a simple application of matte color to define areas of light and shadow.

2. Next, tint this base color with white or a similarly light tone, blend it with a gloss medium, and apply it where you would like the appearance of reflected light.

3. Once this first layer is dry, add the next. Work slowly: it's better to add several subtle glazes than fewer thick ones. Continue building your glazes until you're happy with the result.

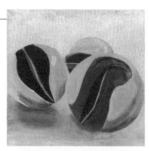

step 1

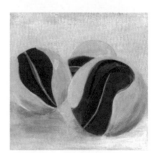

step 2

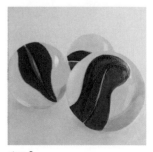

step 3

NOW GET MORE CREATIVE

EXPERIMENT WITH CRACKLE PASTE

Crackle Paste is an interesting medium. As the name suggests, it splits as it dries, producing a cracked surface that is ideal for achieving an antique or weathered look, or a broken-glass effect. The size and pattern of the cracks will vary depending on the thickness of the paste layer, whether it has been mixed with paint or not, and environmental conditions such as temperature and humidity. Crackle Paste dries to a semi-absorbent, opaque, and matte finish, so you can paint washes of acrylic on top to add color and enhance the crackle effect.

For this technique it is advisable to use a rigid surface such as a board or canvas board, because too much flexibility will result in the paste cracking and falling off. Note, too, that Crackle Paste will shrink slightly as it dries, making the results somewhat unpredictable, although this is also what makes it so fun to use. If you'd like to try to replicate results, keep a note of your working conditions so as to control the reactions of the paste as much as possible.

Opposite: Fluid acrylic paint layered over Crackle Paste creates a highly textured work.

TRY IT YOURSELF

1. Start by preparing your surface. For greater impact, paint a layer of color as a base and, once dry, apply the Crackle Paste on top using a palette knife. The base color will then show through wherever the paste splits.

2. Cracks tend to form in the direction that you work your knife in, so apply the paste in a swirling manner to encourage cracking all over the surface. Let it dry overnight, or longer if the weather is humid, wet, or cold.

3. Once the Crackle Paste is fully dry, you can apply color on top in thin washes, creating a bleeding effect, almost like watercolor. You will find the dry surface provides great absorbency. Blot away some of the color with a paper towel if you want to lighten areas of the work or reduce the color intensity.

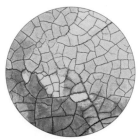

ADD TEXTURE WITH MOLDING PASTE

Molding paste, or modeling paste, has a thick consistency that can be used to create different textures within a painting. Mix it with acrylic paint to add body and texture to your work without sacrificing the color's opacity.

There are different densities of molding paste available: light, regular, and hard. Light molding paste has a soft and airy texture, and can be used to add body without increasing weight. Hard molding paste has a thick, waxy consistency and dries to a very resilient, matte, opaque finish. Denser than other molding pastes, once thoroughly dry it can be sanded by hand, or carved and scratched with tools. Regular molding paste falls between the two.

Molding paste can be applied to any rigid surface with a palette knife. You can add color to the paste before applying it, or you can wait for it to dry and then paint over it for bright, saturated color.

Be aware that there will be some shrinkage when the paste dries, and it will recede in depth to about a third.

TRY IT YOURSELF

Make patterns
Apply molding paste to a board and shape it with a palette knife. Try using the edge of the knife to make patterns in the paste.

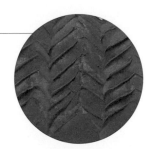

Use cling wrap
Apply a thick layer of light molding paste and cover it with cling wrap while it is still wet. Move the film around to imprint creases on the paste. Once you are satisfied, remove the wrap and leave the paste to dry.

Use a syringe
Squeeze the paste through the nozzle of a large syringe. This degree of control will allow you to create highly intricate textures and patterns quickly and easily.

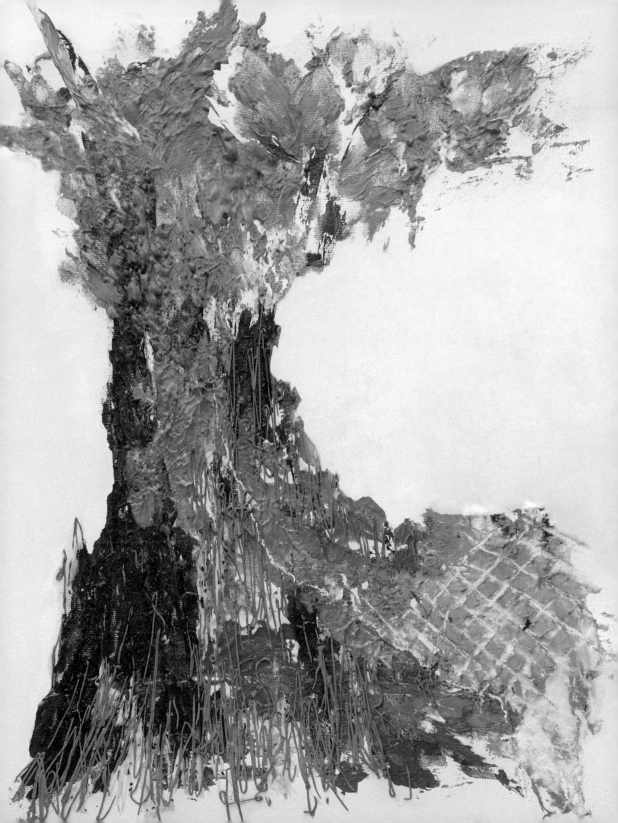

HAVE FUN WITH COLLAGE

Opposite: Jesús Perea, *Abstract Composition 642*, mixed media, 2015

The versatility of acrylic makes it ideal for collage work: you can use it as a glue to stick layers of paper together, as the artist Jesús Perea did to form the work opposite, combine it with acrylic mediums such as Crackle Paste (see page 58) to create textured effects, or apply layers of thinned or opaque paint over the surface to add color.

Acrylic's quick drying time is also beneficial when building up multiple layers, so take advantage of this and try overlapping different papers (tissue paper, newspaper, magazine cutouts, and so on), using the paint to stick the layers together. You can also use soft gel medium, self-leveling medium, and pourable acrylic gel, all of which dry completely clear.

Further ways to experiment include ripping layers and unveiling what's underneath, adding texture by using sandpaper on certain sections of the work, and alternating different colored paints between the layers of your collage.

It's advisable to smooth each layer down gently before you add the next, to avoid air bubbles. Then leave your work to dry flat once you're done, preferably with something heavy on top to press all the layers together.

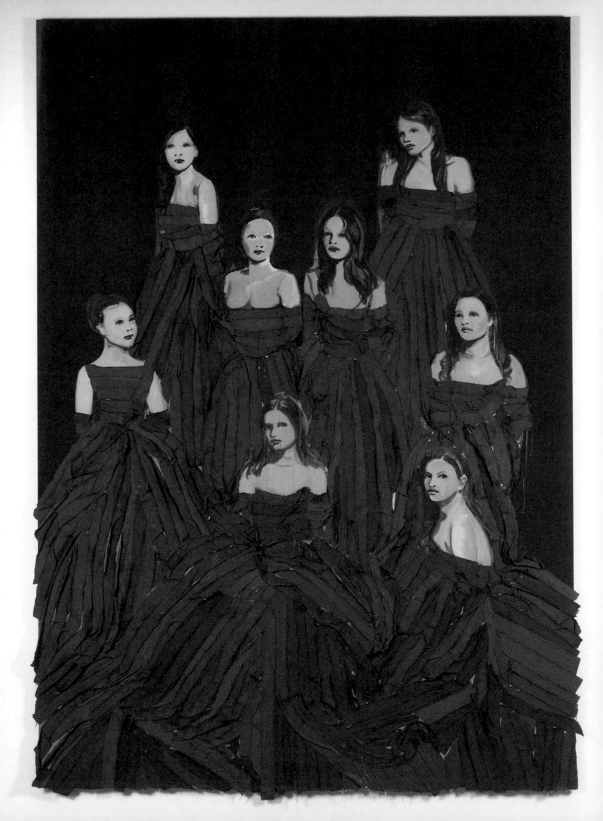

PAINT WITH FABRIC

Opposite: Claire Tabouret, *Les Débutantes (Dark blue)*, acrylic and textiles on canvas, 330 x 230cm, private collection, photo © bluntbangs.biz

Combining acrylic paint with fabric can add a striking textural dimension to an artwork. Soft, light materials work best—ribbon, felt, or lace, for example—as they are highly flexible and easy to manipulate across any sturdy surface, such as properly primed linen canvas, wooden board, or metal.

Preparation depends on the type of fabric you're using, the consistency of your paint, and the desired outcome. If, for example, you want to use the staining technique (see page 38) on a light, soft cotton weave, you can either prime it beforehand to prevent bleeding, or leave it raw and watch the colors sink in and spread. If the weave is tighter, as with a linen, and the paint thicker, you will not need to prime the fabric, as the paint won't compromise the threads.

TRY IT YOURSELF

1. Form a background by applying a base layer of color on which you can build a composition and apply the fabric.

2. Secure the fabric with an acrylic medium (GAC 100 binder or soft gel, for example), as this will bind the cloth to the surface once dry. If creating a highly textured work, you can also apply thick layers of paint and then mold the cloth onto this, twisting it around for a textured, dynamic result.

3. You can use colored fabric—as Claire Tabouret has done in the work opposite—or you can paint the fabric using the dry brush technique (see page 26) to enhance the weave texture. You can also layer heavy strokes of paint to build an impasto (see page 44). Experiment and see what you can create.

DISCOVER MONOPRINTING

Acrylic can also be combined with printmaking techniques such as monoprinting, a one-off impression created when paper is pressed against a painted printing plate. The plate can be repainted several times, so you can produce layered compositions with great depth. The artist Hannah Klaus Hunter, for instance, made four separate impressions to create the work opposite.

You will need a non-absorbent plate from which to print or lift impressions onto your paper. This can be a Gelli Plate or a sheet of glass. You will also need a brayer, or small roller, to roll the ink across the plate.

If you are new to monoprinting, you can simply use basic printing paper dampened with a few sprays of water from an atomizer bottle, which will improve the transference of color. Just be careful not to wet the surface too much or your print will be blurry.

You can use different consistencies of acrylic for this technique, but slow-drying paints will give you more time to work on your impressions.

TRY IT YOURSELF

1. Drop a small amount of paint onto the plate and roll the brayer backward and forward across the surface to make sure it is covered evenly.

2. Place textured items such as nets, leaves, or string on the painted surface. You can also try "drawing" directly onto the plate by wiping away areas of wet paint before taking a print.

3. Place a sheet of paper on the painted plate and press evenly across the whole surface. Use a clean roller to increase the pressure and allow the paper to pick up more paint. Then carefully lift the sheet of paper to reveal your beautiful monoprint.

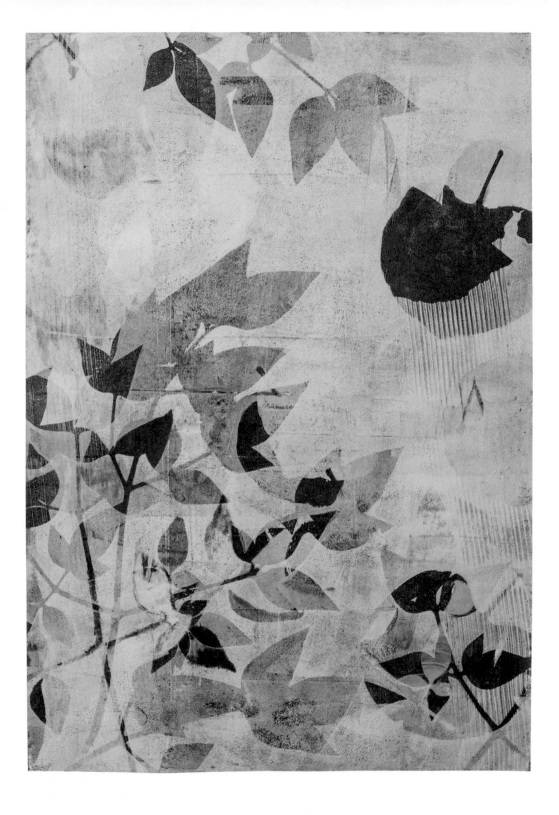

TRY A SIMPLE IMAGE TRANSFER

Opposite:
The finished
transfer—note
that the image
has been flipped
in the process.

Acrylic polymers are a type of medium that form transparent and malleable seals, almost like a plastic film. You can also use them to create a kind of synthetic skin that retains color and images when dry—a process known as a simple image transfer.

For best results, use a clear soft-body gel or a leveling medium, such as pouring medium, as your polymer. In the work opposite, for instance, a photograph was transferred onto a thin layer of soft-body gel. The acrylic retains the image, becoming the surface of the artwork.

Bear in mind that a matte medium might give your image a cloudy finish, while gloss mediums will guarantee a clear image that can be varnished to a matte finish after the transfer is complete and fully dry. The mediums will have a white, milky color when wet, but never fear— they will become fully clear once dry.

TRY IT YOURSELF

1. Print the image you want to transfer. The thinner the paper, the easier it will be to transfer the image onto the acrylic medium.

2. Cover your image evenly with soft-body gel and leave it to dry. It is important to have a resilient acrylic film, so you might want to repeat this step several times, making sure each layer is thoroughly dry before applying the next.

3. Once the gel is completely dry, wet the paper onto which the image was printed and start rubbing it away (you can use an eraser or just rub with your fingers) to reveal your image imprinted on the acrylic polymer.

SHARPEN YOUR OUTLINES WITH MASKING

Because acrylic paint tends to dry quite quickly, it is naturally well suited to creating sharp outlines and delineated edges (see page 32). On a more practical level, masks can help protect one part of a painting from spray, drips, or bleeding while you are working with more fluid paint on another part of the composition. You can also mask off sections that have been previously painted to create definite layers in your work, or even crisscross masking tape to create patterned effects.

1. Cut a mask from a piece of cardboard and place it on the area that you want to remain free from paint.

2. Apply either soft- or heavy-body paint to the uncovered areas. You can move your mask around to create a detailed pattern.

3. Once your chosen areas have been blocked in and have dried, you can work on different areas, perhaps using a different technique, such as dry brushing (see page 26), to add further interest.

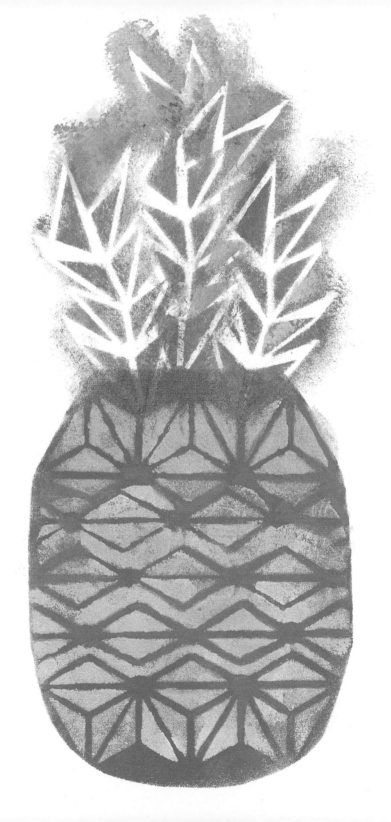

MAKE YOUR OWN STENCIL

A stencil is a cutout that allows you to create well-defined images and lettering repeatedly. Stencils vary in size, making them useful for anything from tiny greetings cards to large-scale murals, as the powerful work of Mando Marie demonstrates opposite.

Stencils are commonly made from sheets of nonabsorbent materials such as oiled manila card, stencil card, or acetate, which can be easily wiped clean and reused. However, if you're a beginner, any paper or card will do.

Once you have your stencil, you can fill it in with paint using a sponge, a stubby brush, or a spray can, depending on the scale of your composition. Marie, for instance, uses a stencil to create a defined outline and then shades her figures using a mixture of brushwork and aerosol spray.

TRY IT YOURSELF

1. Draw your desired shape on a piece of card and cut it out using a craft knife.

2. Place the stencil on the surface, securing it in place with masking tape.

3. Using either a dry round flat brush with stiff bristles or a dry foam brush, lift a small amount of paint, removing any excess on a palette, and dab it repeatedly onto the stencil's open areas to build up the color. Make sure there isn't too much paint on your brush—any excess will seep under the stencil and muddy the edges of your shape.

Mando Marie, *Ascenders*, spray paint on canvas, 2017

GET CREATIVE WITH ACRYLIC MARKERS

Acrylic marker pens combine the saturation and fluidity of acrylic paint with the tighter control of a pen, making them ideal for painting fine lines and intricate details.

There are several brands of acrylic marker available, the majority of which are highly pigmented, resulting in vibrant opaque colors that are long-lasting. Acrylic markers also come with a range of nib sizes for an array of different line widths, so they can be used both for fine detail and for filling in larger blocks of color. You can use them on a wide range of surfaces, too, from paper, canvas, and walls to glass, clothes, and even shoes!

Opposite: A range of acrylic markers with various nib shapes—flat, chisel, and fine liner—were used to create this composition.

TRY IT YOURSELF

Hold the pen vertically
Try holding your pen vertically, then drag it across the surface, without pressing too hard, to create clear, sharp lines.

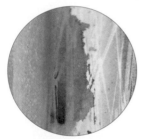

Mix paints together
Press the nib down to release more paint, then, using a brush or your finger, mix different colors together.

Mimic dry brushing
To create a "scratchy" brushstroke similar to that produced by dry brushing (see page 26), adding expression and movement to your work, press the nib down very gently as you pull it across the page.

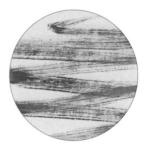

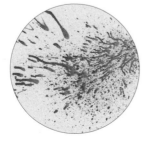

Use your breath
You can make a punchy splatter by holding your pen close to the surface and blowing directly on its tip, in the direction of the page.

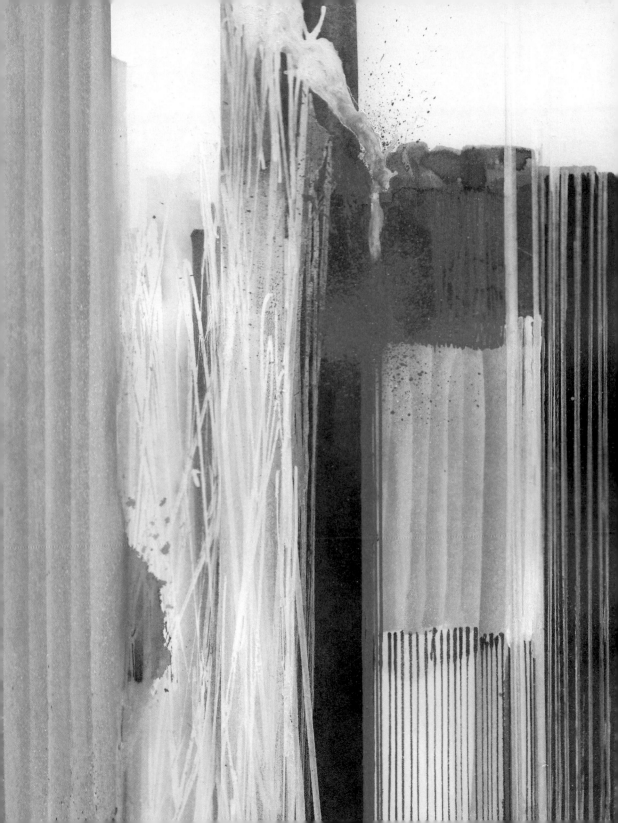

SPRAY YOUR PAINT

Opposite:
Yann Chatelin,
Bujubomba,
acrylic and
ink on canvas,
2018

Spray paints are often associated with graffiti art and outdoor murals because of their vibrant colors, smooth finish, and resilience, and the fact that they allow you to cover large areas rapidly. What you may not know, however, is that spray paint is versatile enough to be used successfully on a range of different surfaces. For the work opposite, for instance, the artist combined spray paint with acrylic ink on canvas to create a colorful artwork infused with a street-art quality.

It's best to use pigmented acrylic spray paints to ensure the color maintains its vibrancy. There are several brands available, and many different finishes, such as gloss, matte, glitter, and even glow-in-the-dark. Note that some products will dry more quickly than others.

If you want to combine spray paint and traditional brushwork in the same piece, you may wish to mask off sections of your canvas before applying the spray paint (see page 70).

Please note that it is a good idea to wear a dust mask while working with spray paint.

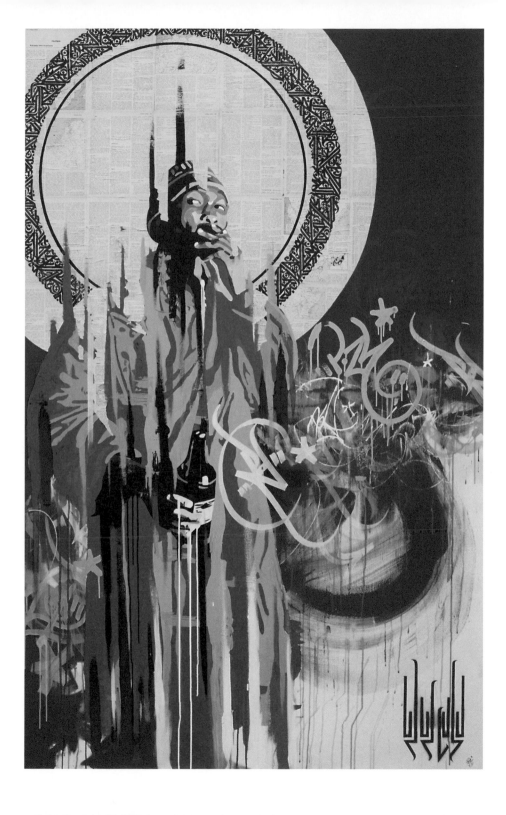

DRIZZLE AND DRIP WITH STRING GEL

Opposite:
Mary Arkless,
*Painting the
Blues*, acrylic
and String Gel
on canvas, 2016

String Gel is an acrylic medium with a thick, honey-like consistency that you can pour, drizzle, or drip directly onto your canvas to create string-like textures and colorful, abstract works. Mix it with acrylic paint to "draw" colored lines, patterns, and textures across your surface, or apply it straight from the tube and paint over it with washes of acrylic paint when dry. This is a useful technique for highlighting details in a composition, or for adding texture to objects such as trees and flowers.

TRY IT YOURSELF

1. Mix a small amount of String Gel with soft-body acrylic in a pot or on a palette.

2. Apply the colored mixture to the canvas by pouring it from above, dripping it with a nozzle or flicking it with a brush.

3. Leave each layer to dry before applying the next one to create a wonderfully textured work. (You can also apply new layers while previous layers are still wet to create an even layer of color.)

dripped String Gel

drizzled String Gel

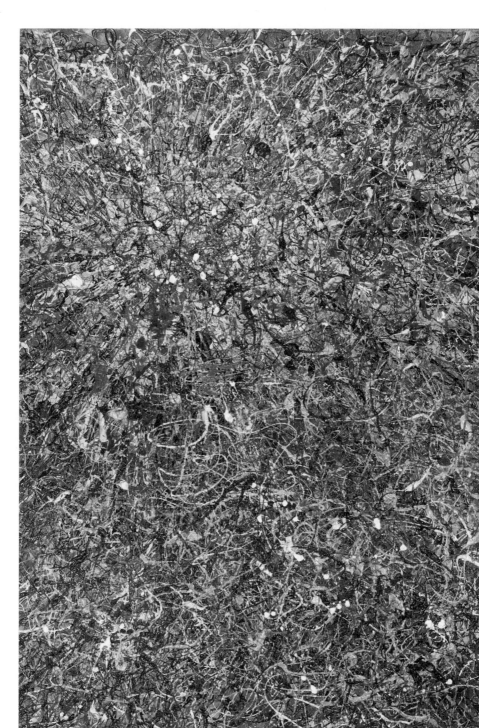

THE STRING PULL TECHNIQUE

Opposite:
Acrylic ink
on 140lb
watercolor
paper.

Acrylic inks are an exceptionally fluid form of acrylic paint. They are quick-drying and can achieve the same fluidity and brilliance as drawing inks—traditionally used for calligraphy—but with a higher opacity and brighter colors. Acrylic inks are also highly versatile and can be used on almost any surface, including paper, wood, fabric, and plastic. They can be thinned down for transparent glazes or used opaquely for flat, bold areas of color.

You can apply acrylic ink with traditional brushes, but it can be just as rewarding to use unconventional methods, such as string. This unlikely tool can be used to create beautifully delicate flowers and botanical prints.

When attempting this technique, you will need to use a pliable support, such as paper or unprimed fabric.

TRY IT YOURSELF

1. Dip a piece of string in a bowl of acrylic ink until it's thoroughly soaked, then remove the excess ink by running it between two fingers as you pull it out of the bowl (make sure you're wearing gloves!).

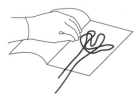 **2.** Arrange the string on the support as desired. If you want to create a flower, for instance, fold the string into itself so that it loosely forms the shape of an "8," with an "s" on top. Make sure to leave one end of the string hanging off the edge of the paper.

3. Cover it with another sheet of paper and a flat weight, such as a book or tray, and keep this in place as you pull the string from between the two sheets.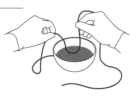

 4. Gently lift the paper to reveal a beautiful mirrored print.

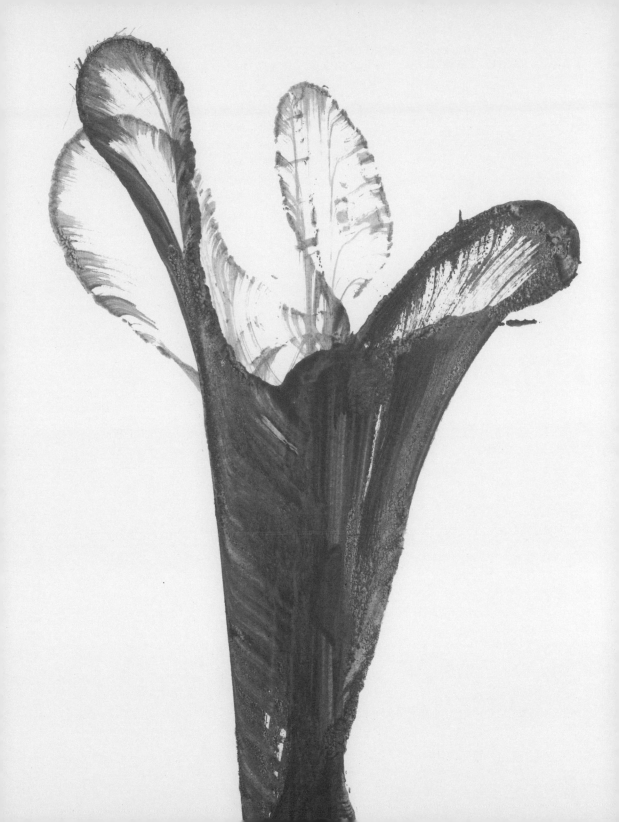

PAINT ON PAPER

Opposite: Evan Jones, *Roses and Clover*, acrylic on paper, 2018

Acrylic paint can be used on paper to achieve all sorts of techniques and results: it can be used for quick sketches, applied to sketchbooks for decoration, combined with water-soluble drawing materials such as crayons or graphite, or thinned down for a watercolor effect, to mention just a few examples!

The heavier the paper, the more liquid it will withstand. Papers with 140lb or more will receive soft-body acrylic and even fluid inks with little warping. The artist Evan Jones likes to work *alla prima* (wet-on-wet), so he used 200lb acrylic paper to create the work opposite. This particular paper has a simulated canvas texture that holds the paint better, he finds.

To increase the paper's absorbency and make it more even, you can prepare it as you would a canvas by applying a primer or ground that will provide a better grip for thicker layers of acrylic, and reduce the tendency to warp (see page 20). Conversely, though, this will reduce the paint's ability to bleed if you're applying thinned washes.

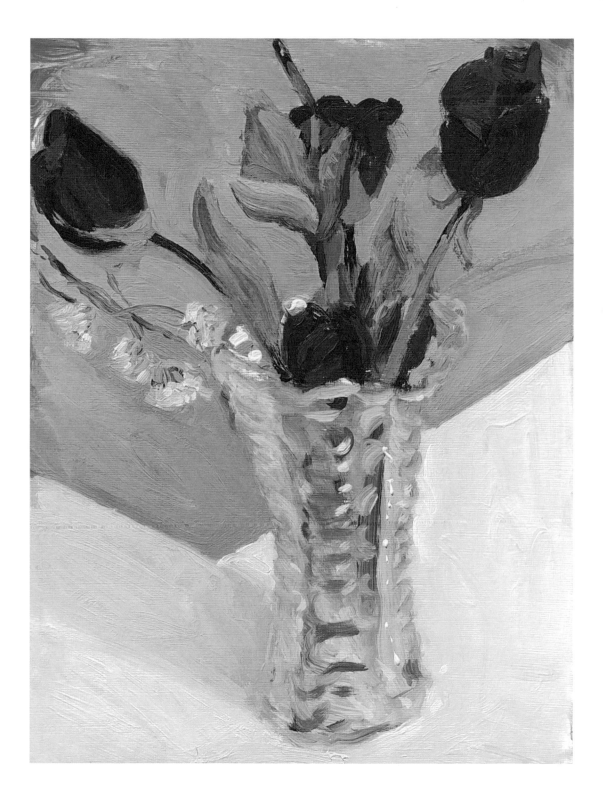

PAINT ON WOOD

Applying acrylic paint to wood is an exciting way to add texture to a painting or to brighten up your home. Why not use a wooden panel instead of a canvas for an earthy background, or update some wooden furniture with bright, opaque layers of acrylic paint? Wood is also sturdy and stable, making it perfectly suited to techniques that require palette knives and a slightly rougher painting style, such as impasto (see page 44).

Wood can be more or less absorbent, depending on how you prepare it. If raw (unvarnished), wood offers a great grip to acrylic paint. To increase its porosity and make sure that colors will be absorbed evenly, sand and prime (see page 20) the wood beforehand. You can sand it to a smooth, flat surface, or embrace its natural patterns, crevices, and flaws by including them in your composition.

It's worth noting that wood isn't acid-free, so to avoid discoloration over time it is important to apply a sealant such as GAC 100 or GAC 700 before priming it. Make sure to let the sealant dry before adding the primer.

Lena Schmidt, *Entenwerder No.1*, acrylic marker and paint on wood, 2015

PAINT ON GLASS

Opposite:
Oliver Dorfer,
Azulejo 1,
acrylic on
acrylic glass,
2014

Glass may be a less familiar artistic surface, but it can be employed to create stunning artworks—just take Oliver Dorfer's beautiful work opposite. You can use either opaque colors, for a strong contrast, or translucent washes, for a more delicate effect.

When applying acrylic paint to glass, tiles, or similarly smooth and non-absorbent surfaces, it is essential to create some grip by adding porosity. Luckily, there are several ways to turn glass into a suitable ground for acrylic, the most common being sanding and etching.

To sand the glass, use a sandpaper sheet or a sanding block with a medium grain. This will make the surface irregular, and the grain created will form a suitable surface for the acrylic. Once the surface looks slightly foggy and feels rougher, you can apply your paint.

Another option is to use an etching cream. These are readily available in hardware stores and have an abrasive effect on the glass, giving it a fine tooth. Just follow the manufacturer's instructions and safety warnings carefully.

To enhance your results, you can add GAC 200 medium to your paint, to improve adhesion to non-porous surfaces. On its own this is usually not enough to form a permanent bond, but if combined with the etching/sanding of the glass, it will help your artwork last longer.

acrylic on glass that hasn't been prepared

acrylic on sanded glass

PAINT ON METAL

Fast-drying, resilient, and colorful, acrylic is one of the best paints to use on metal. You can either paint over a metallic surface with a translucent glaze (see page 54) to allow the surface to show through in your work, or simply use it as a rigid surface when working with palette knives. You can also achieve interesting results by embellishing metal objects with acrylic markers (see page 74) and, as metal is nonabsorbent, it will also allow you to experiment with removing sections of paint once you have applied it, either by wiping it away before it dries, or by using techniques such as sgraffito (see page 48) to reveal hints of metallic sheen in your work.

To increase the adhesion of the acrylic paint, all you need to do is lightly sand the metal surface and then apply an appropriate primer. There are many brands available, for both indoor and outdoor work, and these can be applied with a brush or as a spray.

To create the work opposite, the artist Charly Baxter planned her composition first, plotting out where the metal would remain visible and which areas would be covered with paint. Baxter then applied two layers of gesso to the sections that were to be painted over. Once this was dry, she started painting, applying several layers where she wanted to achieve solid colors. If, as in the work opposite, the metal is quite rough and rusted, Baxter leaves the finished painting unsealed; if, however, it's a particularly smooth metal, she seals it with varnish, because smooth metals are more prone to scratching.

Charly Baxter, *Driving into Town*, acrylic on black iron, 2016

MIX ACRYLIC AND OIL PAINTS

Opposite:
Sarah Hardy-
Box, *Saturday
Night*, acrylic
and oil on
birch panel,
2019

Typically, artists avoid mixing water-based acrylic paint with oil paint because of the fact that water and oil do not mix. However, some artists are harnessing this creative partnership's potential.

In *Saturday Night* (opposite), Sarah Hardy-Box applied a vibrant, abstract underpainting in green shades using acrylic, then added oil paint in darker tones on top, to obscure and reveal elements of the underpainting. Finally, she added small amounts of bright yellow/green oil paint to add texture and interest to the foreground.

Bear in mind that oil paint usually dries to a gloss finish, so if you're interested in creating strong contrasts and depth, combine it with matte-finish acrylics. Or, for a uniformly glossy finish, mix your acrylic paint with a gloss medium.

TRY IT YOURSELF

1. Apply an underpainting layer of acrylic color (any type will do) to form the ground. You can paint this as a thin wash or a flat opaque layer. Let dry.

2. Apply the oil paint thickly over the acrylic and then scrape it back partially to create a sgraffito effect (see page 48) that reveals the acrylic underneath.

3. Alternatively, thin down the oil paint with spirits or a low-odor solvent to form a translucent glaze. When layering, though, remember always to apply oil *over* acrylic.

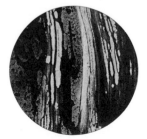

4. By diluting the oil paint further, you can also create a marbled finish.

ENLIVEN YOUR WORK WITH MARBLE DUST

Marble dust is a very useful tool for acrylic painters: it can be used to thicken paint, giving it more body and a slightly chalky texture, or simply to add an eye-catching sheen to your paints.

To create *Fjord Echo* (opposite), Sarah Winkler added marble dust at different stages. First, she mixed the marble powder with acrylic gesso to prime the panel and give it a pleasing texture. She then mixed marble dust with white acrylic paint and used this to lighten other colors, giving her composition a lovely sheen that glimmers when it catches the light.

Because marble dust is white and slightly pearlescent, it will either lighten the colors it is mixed with or add a subtle polish to your whites. If you want to achieve a completely smooth, porcelainlike surface, you can sand each layer of gesso (between three and five coats is recommended), resulting in a flat and smooth finish that still retains some porosity. Alternatively, sand and scratch the top layer in different directions to create peaks and crevasses.

Be careful when mixing marble dust with gesso or paint. Pour it slowly and use a protective mask and gloves to avoid inhaling the dust.

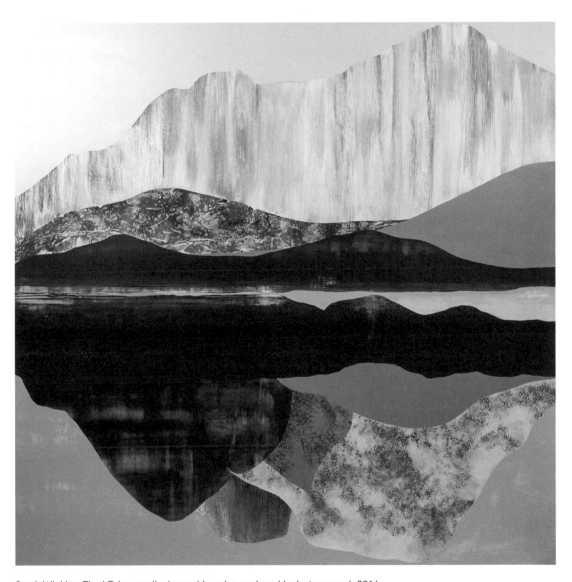

Sarah Winkler, *Fjord Echo*, acrylic, iron oxide, mica, and marble dust on panel, 2016

ADD SHIMMER WITH IRIDESCENT MEDIUM

Opposite:
Shannon Finley,
*Rhombus
(Electric Milk)*,
acrylic and
Iridescent
Medium on
canvas, 2013

An alternative to ready-mixed iridescent paint, Iridescent Medium offers a brilliant way to add luminosity and sparkle to your work, as seen opposite in a shimmery abstract piece by Shannon Finley. Iridescent Medium can be applied underneath acrylic paint for beautiful pearlescent effects, or applied as a glaze on top of existing areas of color.

If you wish to retain brush marks and create texture in your work, use a bristle brush and a palette knife; a synthetic brush will give you a smoother finish. Iridescent Medium is opaque when wet, but it dries translucent so will hardly affect the paint's color.

TRY IT YOURSELF

Paint acrylic over Iridescent Medium
Using any type of brush, apply a layer of Iridescent Medium to form your background and, once this is dry, apply thin glazes of acrylic paint over it (see page 54). This will give your colors a very subtle pearlescent quality.

Paint Iridescent Medium over acrylic
Paint your surface with the acrylic paint of your choosing, wait for it to dry, then apply thin layers of Iridescent Medium over the top. This will add a reflective quality to the painting, while preserving the colors underneath.

Add Iridescent Medium to your paint
Enliven your work by mixing a small amount of Iridescent Medium into your paint before you apply it to your surface, for a touch of sparkle.

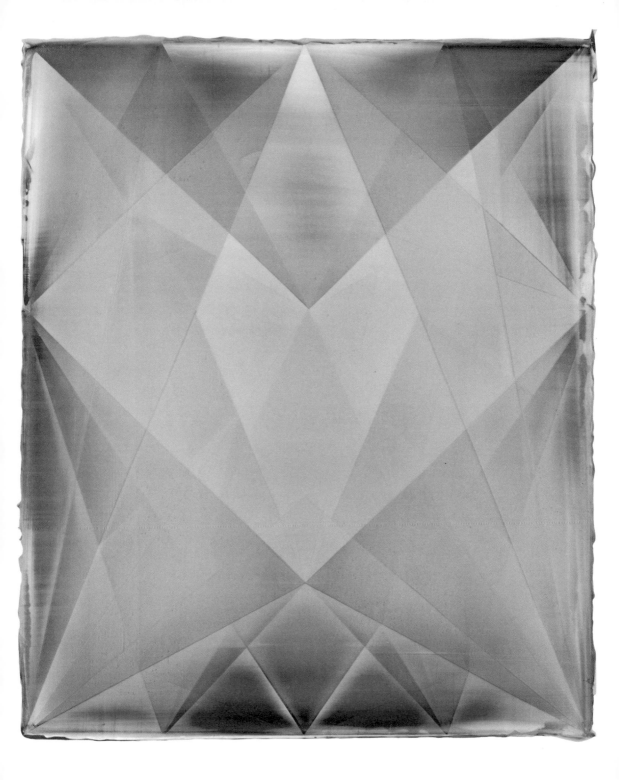

VARY YOUR FINISHES WITH ACRYLIC AND ENAMEL PAINT

Oil-based enamel paints are not an obvious choice to combine with acrylic paint, because oil and water don't mix (see page 91). Despite this, however, acrylic and enamels can be combined successfully in different layers to create various finishes. For example, the artist Lori Larusso frequently uses both paints to create her inviting paintings of cocktails and food. Having used heavy-body acrylic to form the background in *Bourbon Sour*, she used enamel paints with an even thicker consistency to suggest light reflecting off the glass and the cherry, and to bring out such details as the rind on the orange and the floating ice cubes.

When combining acrylic and enamel, Larusso uses sticky stencils, made from contact paper, to form her shapes, applying acrylic paint in the negative space left exposed by the stencil. Once the paint is dry, she removes the stencil, then applies the enamel paint with a medium- or hard-bristled brush, or pours small amounts of it into another stencil, allowing it to settle until it has dried to a raised, slightly glossy finish.

Larusso works on smooth and flat surfaces, such as wood prepared with gesso (see page 20) or polymetal, which enable her to spread the enamel and the acrylic paint more easily.

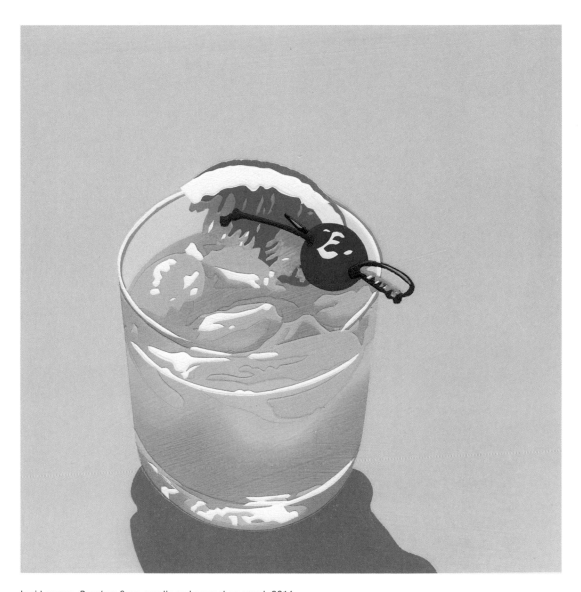

Lori Larusso, *Bourbon Sour*, acrylic and enamel on panel, 2016

ADD LUSTER WITH GOLD LEAF

Acrylic is the perfect paint for those looking to enrich their work with the glimmer of gold. Unlike oil paints, acrylic won't tarnish the gold leaf, making it a much more straightforward proposition. While there are several types of acrylic paint that will dry to a gold finish, gold leaf will add more depth to your work and give it a polished glow. It can be used to add gold highlights, or even to form a lustrous background for your painting.

When working with gold leaf, apply a base layer of color, wait for it to dry, then use a brush to apply size (a specific type of glue for gold leaf) to the areas you wish to apply the gold leaf to. Wait about 10 seconds for it to become tacky, then lay the gold leaf on top, brushing over it with a soft fan brush to smooth out any wrinkles.

In the work opposite, Ang Tsherin Sherpa applied gold leaf over a base layer of black. Once it was thoroughly dry, he rubbed it gently with velvet in small circular movements, bringing the gold to a nice sheen. After this layer was dry, he applied a darker shade of paint in tiny strokes to create an effect that looks like dry brushing (see page 26). This is a traditional Tibetan technique known as *kam dang*.

TRY IT YOURSELF

1. Choose where you want to add the gold leaf and coat these areas with size—acrylic size works best on watercolor paper. Use a small soft-haired brush for the more intricate areas and a flat, broad soft-haired brush for the larger areas. You may need to thin the size with a little water and apply more than one coat to avoid brush marks. Consult the manufacturer's instructions for drying times.

2. Take a sheet of gold leaf, place it face down on the sized surface, and gently rub the back of the transfer paper, making sure to apply pressure only where the gold is present. When covering large areas, overlap the gold sheets by a couple of millimeters so there are no gaps. If you have used metal leaf that needs sealing, wait at least 24 hours before coating your work with a protective lacquer.

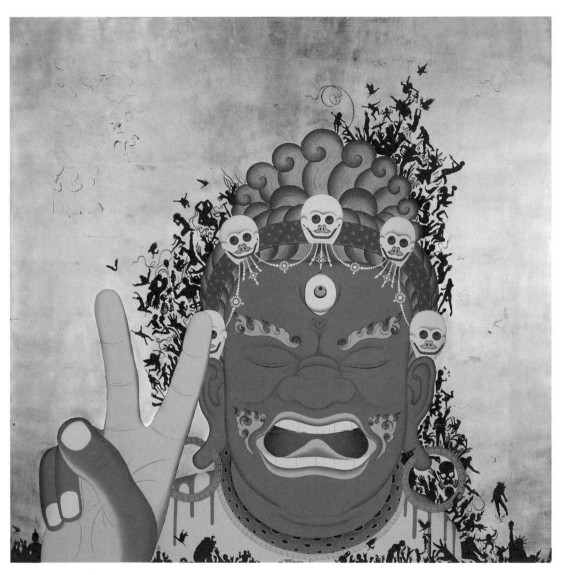

Ang Tsherin Sherpa, *Red Spirit*, gold leaf, acrylic, and ink on cotton, 2011

INJECT COLOR WITH INDOOR MURALS

Opposite: Leah Bartholomew, mural for a private residence, acrylic on plaster wall, 2015

Walls have been used by artists for thousands of years—ever since they first began to paint and draw—and today murals remain a fun, creative way to bring color to indoor spaces. Any acrylic paint can be applied to walls with great results; just make sure the surface is clean, grease-free, dry, and properly primed with wall primer (you can buy indoor and outdoor varieties). Choose soft-body paint for a smooth, flat finish, or heavy-body paint for more textured results.

To make sure your paint remains resilient, and to avoid dripping, do not thin it with water. For optimal results, add GAC 200 to your paint in a ratio of 1:2, to make the paint stronger and help it adhere to less absorbent walls. The bond isn't permanent—it may fade or scratch off over time—but this will increase the durability of your work. You can also use a spray-on varnish to help your work last longer and protect it from scratches.

Stenciling (see page 72) is frequently used in large-scale projects like murals. When stenciling a wall, use large brushes or large foam rollers, which are denser and retain less paint, leaving a uniform, even finish.

FLUID
ART

THE WONDERFUL WORLD OF FLUID ART

The term "fluid art" encompasses a plethora of increasingly popular acrylic pouring techniques that create unique, spontaneous works of art. From simply pouring paint freely down a canvas to using acrylic mediums to encourage surprising textured effects, you can experiment endlessly and have lots of fun! The results of these techniques often appear random, like the work of Arthur Brouthers opposite, but that's their beauty.

As the name suggests, fluid paint is key for these techniques, as you want a consistency that will flow easily, forming beautifully sinuous lines. You can, of course, thin thicker paint with water or flow enhancer, but it's best to use fluid acrylic if you want to maintain bright, saturated color.

If you're working on canvas, it's a good idea to prime it beforehand (see page 20) to give yourself an even surface that's strong enough to withstand lots of paint. Canvas boards also work well.

As you may have gathered, this can be a messy art form, so it's advisable to invest in plastic sheets, a plastic tray, and rubber gloves. Other useful acrylic pouring tools are plastic cups, squeeze bottles, and utensils with which to manipulate the paint, such as sticks and feathers. Silicone oil is a fun addition, as it will create cell-like structures in your work. A heat torch is a bigger investment, but one that will allow you to form even more cells in your compositions.

Intrigued? The next few spreads will explore some of the most interesting fluid art techniques, enabling you to take your acrylic work to the next level.

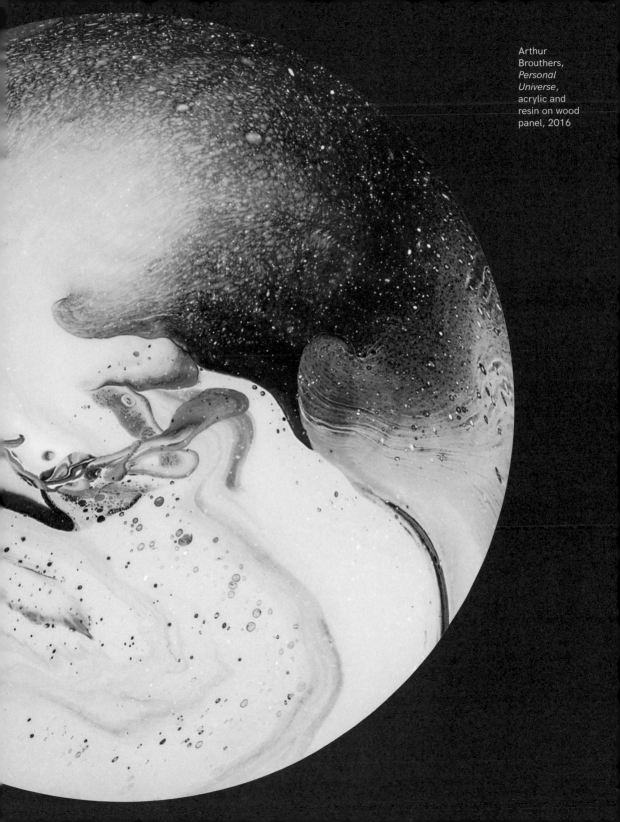

THE DIRTY POUR

Opposite:
A finished
four-color
dirty pour by
Annemarie
Ridderhof.

The dirty pour is one of the most popular fluid art techniques, in which colors are prepared individually and then combined in a tub to pour over the surface. The point is not to blend colors, but to create unpredictable results in the form of beautiful folds and swirls.

For best results, each paint color should be mixed with an acrylic pouring medium separately. Select fluid paints or acrylic inks, as these will combine with the pouring medium more quickly and evenly than heavy-body paint.

How much paint you use for each technique will depend on the size of your canvas and your artistic vision. As a general rule, if you plan on tilting your canvas to stretch cells and create more swirls, you will need more paint. Bear in mind that thinner paints will stretch farther than those with thicker consistencies.

TRY IT YOURSELF

1. Prepare each color by mixing acrylic pouring medium with a smaller proportion of paint (about 3:1). Then add a couple of drops of fluid silicone oil to each color and mix evenly in a folding motion.

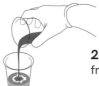

2. Pour each mixture into the same cup, always from the center. Stir this mixture once.

3. Now place your canvas on the cup's rim. Then, in one swift movement, and taking care to maintain the pressure between the canvas and the cup, turn them both over, so that the cup is now face-down on the canvas.

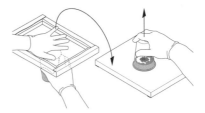

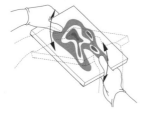

4. Remove the cup in a single swift movement and gently tilt the canvas to spread the paint naturally. You can torch the paint with a heat gun at this stage to create even more cells in your work.

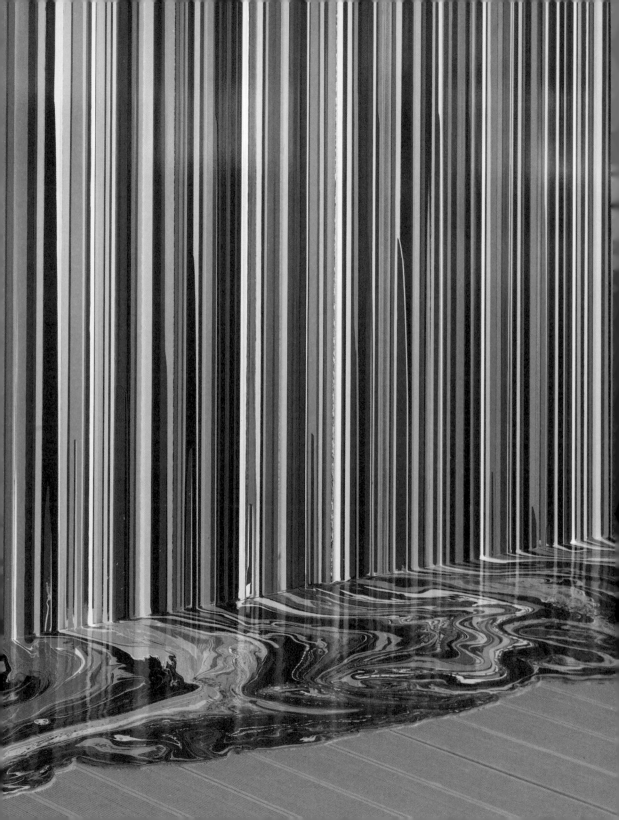

CREATE A COLORFALL

Opposite: Ian Davenport, *Giardini Colourfall*, acrylic paint on aluminum panel, 2017

In the work opposite, the artist Ian Davenport did not freely pour copious amounts of paint from the top edge of his surface, but released the paint from a syringe to control the results with precision. The support, made from aluminum, was positioned vertically, allowing the acrylic to flow from the top, creating vertical parallel stripes down its length to form a sumptuous acrylic tapestry.

Fluid or soft-body acrylic works best for colorfalling. You want a consistency that will flow down the support without being too runny—acrylic ink, for instance, won't maintain individual lines. If you're using heavy-body paint, mix it with a pouring or leveling medium to ensure a good flow.

You can use fluid acrylics on all sorts of surfaces, provided they are smooth and resilient. (If you are using paper, make sure it's at least 140lb.) If you are working on a nonabsorbent surface, such as metal, the paint can even be peeled off once it is dry, and molded into 3D objects! Davenport allowed the paint that accumulated at the bottom of his support to form a beautiful extension of his artwork, capturing the sinuous movements of the paint.

FLUID ART INSPIRATION

Now you've been introduced to the basics of pouring, you can try a brilliant array of techniques. The artist Annemarie Ridderhof has selected a few of her favorites to get you started:

The angel-wing pour

To create your wings, layer as many paints as you like into a single cup (without adding any silicone oil). Then, working on a tilted canvas and holding the cup 1 inch from the surface, pour the paint from the raised edge. Move the cup up and down as you pour to form lines roughly half an inch long. Once you've finished pouring, gently tilt the canvas from side to side, allowing the paint to flow and bleed until you're happy with the shape of your wings.

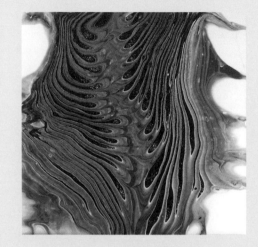

The colander pour

Flood your canvas with a single color (don't add any silicone oil to this paint, as it will cause dimples to form in your background). Now place a colander in the center of the wet surface and pour separate colors, or a single dirty pour, into the middle of the colander. The paint will form a pattern and slowly spread.

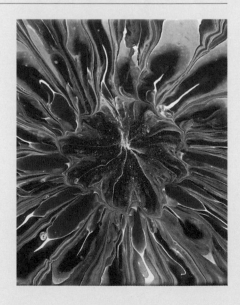

The bottle-cap pour

Pour a layer of paint onto the canvas and use a brush or large palette knife to spread it evenly. Once the canvas is fully covered, layer paint into a selection of bottle caps, using each color several times. How many caps you use and how much paint goes into each one is up to you. Once your caps are full, flip them onto the wet background paint, dragging the caps into position across the canvas. When you're happy with their position, start to lift each cap slightly, moving it over the canvas to release all the paint. When all the caps are empty you can torch the paint or leave it as it is.

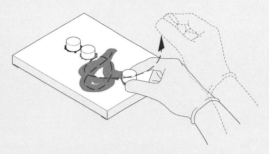

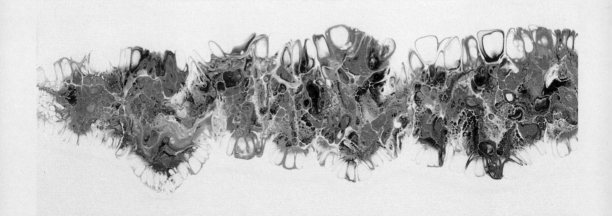

The balloon-ribbon pour

This is a simple yet effective technique. First, paint the canvas in a color of your choosing. While this base layer is still wet, pour three or four colors—prepared separately and each containing a few drops of silicone oil—onto the canvas, one on top of the other, to form little puddles. You can make as many puddles as you like, but they shouldn't exceed 2 inches in diameter or you will lose the effect. Now take a blown-up balloon, big enough to cover the whole puddle, and press it down on top of each one briefly. You can either torch the puddles with a heat gun at this stage or leave them as they are.

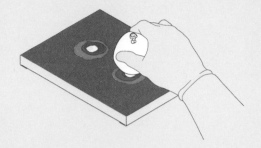

Once you have finished working on the circles, take the leftover paint, layer it in a cup, and pour ribbons horizontally and vertically to connect the circles. You can torch the ribbons or leave them as they are.

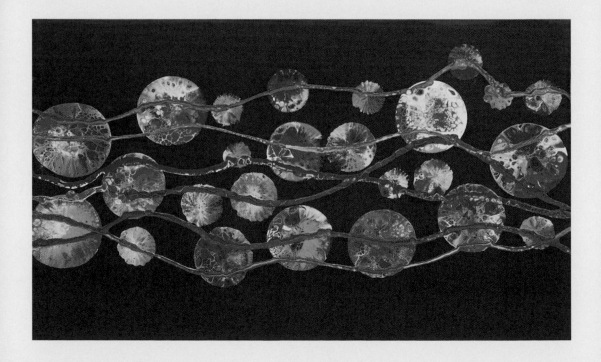

The open-cup push-pull

This is a great way to create beautiful cells. Start by flooding the canvas with a solid color that's free from silicone oil. Next, remove the bottom from a plastic cup and place what remains on the wet surface, ensuring that the cup's rim makes full contact with the canvas.

Now pour different colors into the open cup, layering as many as you like. You can pour a little more of your background color around the cup at this point, to ensure that the colors in your cup are fully surrounded by the background color. Now push and pull the open cup over your canvas. The colors will slowly ooze out and spread underneath the background color. When you are ready, tilt the canvas to spread the paint, and watch the lovely cells form.

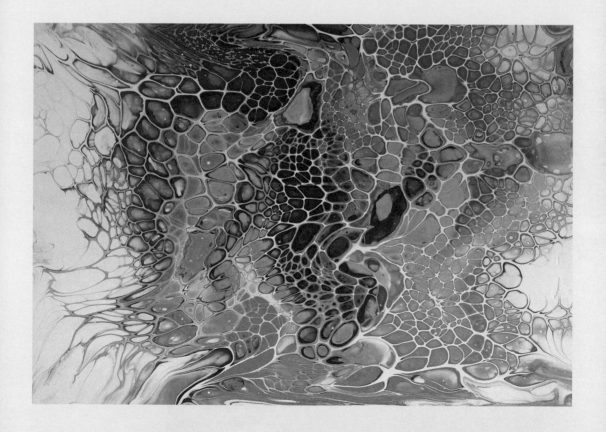

MAKE PATTERNS WITH MARBLING

Marbling is a very popular technique in which striking patterns are created by floating paints on either pure water or water mixed with a thickening agent, and then transferred onto paper. It's best to use a fluid or high-flow paint that will spread across the water's surface without blending completely, creating meandering and dynamic swirls and shapes.

Acrylic paint is water-based, so to prevent it from becoming diluted once in the water, the water's density must be increased. This can be done by adding cornstarch or a ready-mixed marbling solution, which will give you greater control over the movement of the paint on the surface. For best results use a good-quality paper of at least 90lb, with a smooth surface. Marbling can also be applied to objects, such as fabric, canvas board, and gesso board, by dipping them into vats of ink.

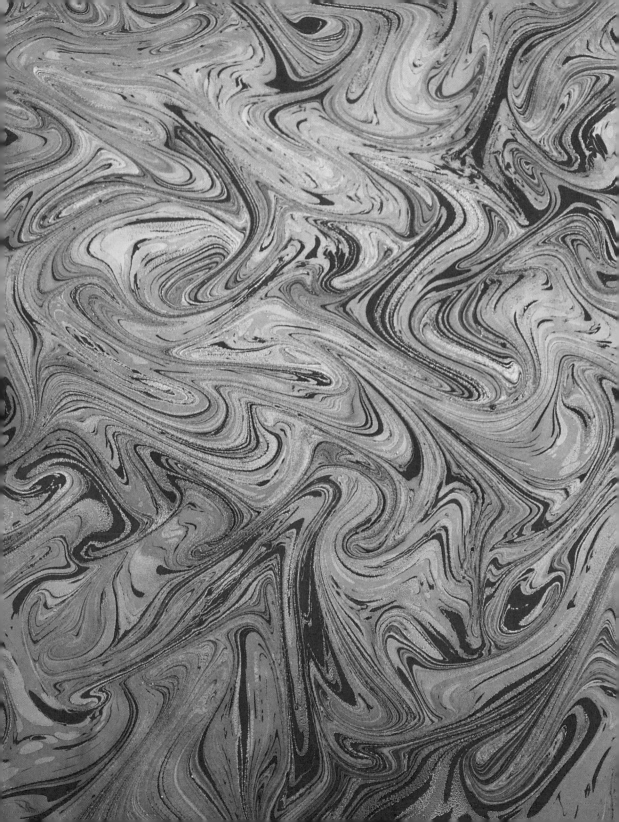

1. Add cornstarch to your water (roughly 2 or 3 tablespoons for every 5 fl oz) and heat it while stirring, until it thickens slightly. You may prefer to use a ready-mixed marbling solution instead.

2. Pour the thickened water into a flat tray that's big enough to accommodate the surface you want to marble, then let cool. In the meantime, prepare a second tray of the same size, filled with fresh water. When the thickened water is cool, add your fluid acrylic paints, one by one, starting with the colors that you want to be most prominent in your composition.

3. Work the paints into patterns by dragging and swirling them around using the tool of your choice—brush handles, toothpicks, and combs all work well. Lie your sheet of paper flat on top of the floating paint, then remove it, lifting it up by opposite corners. The paper will pick up the paint as if it were a transfer.

4. Rinse the paper swiftly but gently in the tray containing clean water, then set it aside to dry flat on a sheet of newspaper or wire rack.

MEET OUR CONTRIBUTORS

Mary Arkless
facebook.com/maryarklessart
The artist Mary Arkless experiments with a wide range of mixed media techniques, be it string gel or fluid art, and aims to maximize texture and color in her pieces. She lives and works in Perth, Australia, where she also runs art workshops.

Leah Bartholomew
leahbartholomew.net
Leah Bartholomew is an artist and designer whose bright abstract creations are inspired by the lush landscape of Byron Bay, Australia, where she lives. Bartholomew's artworks have been featured in numerous exhibitions, and she collaborates with brands internationally, producing unique designs in her signature style.

Charly Baxter
charlybaxter.com
Charly Baxter received her BFA from OCAD University, Toronto, in 2016. Her passion for nature and art has grown since childhood. Based in her hometown, Meaford, Ontario, Charly uses acrylic on metal to create impressionistic landscape paintings, which aim to inspire admiration and respect for the Earth.

Clair Bremner
clairbremnerart.com
Clair Bremner is a contemporary artist based in Melbourne, Australia, who specializes in expressionistic landscape paintings inspired by nature. She uses color, pattern, and repetition to create the sensation of lush environments in her highly decorative pieces.

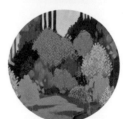

Arthur Brouthers
arthurbrouthers.com
Arthur Brouthers is a pioneer of an abstract fluid painting technique that achieves cellular-like separations with the use of acrylic paints and other chemical agents. Arthur uses up to 15 layers of clear resin between layers of acrylic paint, inks, and spray paint to show depth, creating a 3D effect. He is based in Charlotte, North Carolina.

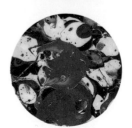

Yan Chatelin
yannchatelin.com

Yann Chatelin is a French-born Casablanca-based artist, whose portraits comment on human fragility and the loss of handwriting brought about by technological dependence. His work is heavily influenced by his background in graffiti.

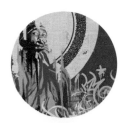

Ian Davenport
iandavenportstudio.com

The British artist Ian Davenport graduated from Goldsmiths College of Art in 1988, and soon afterward was shortlisted for the Turner Prize. Davenport's paintings are driven by a fascination with the process of painting and printmaking. His work has been exhibited extensively and resides in such prestigious institutions as Tate, London, Centre Pompidou, Paris, and the Dallas Museum of Art. He lives and works in London.

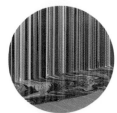

Oliver Dorfer
oliverdorfer.com

Oliver Dorfer was born in Linz, Austria, where he is still based. His energetic, mesmerizing works are full of layered symbols that invite different interpretations from the viewer. He has exhibited widely throughout Europe and the United States.

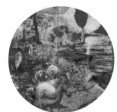

Joanna Maria Dziedzianowicz
saatchiart.com/jmdziedzianowicz

The artist Joanna Maria Dziedzianowicz studied graphics at the Academy of Fine Arts in Warsaw, followed by a master's degree in painting at the University of Lisbon. Her work aims to prove that a human can find a sense of belonging anywhere. She is based in Warsaw.

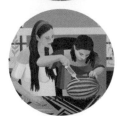

Shannon Finley
shannonfinley.com

The Berlin-based Canadian artist Shannon Finley has exhibited widely in Europe, Canada, and the United States. His works reflect his strong interest in geometric abstraction. Finley is represented by Jessica Silverman Gallery in San Francisco, Carrie Secrist in Chicago, and Walter Storms in Munich.

Sarah Hardy-Box
sarahhardybox.com

The British painter and photographer Sarah Hardy-Box obtained a BFA at the University of Leeds. Her expressive and at times abstract work explores memory, place, and experience. She lives and works in Leeds, England.

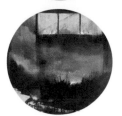

Dan Henderson
d10henderson@outlook.com
Dan Henderson is a jazz bassist who paints abstract art as if he's playing jazz. The result of such a free-form approach is artworks that come from an unexpected place, much like jazz music.

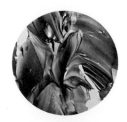

Dan Huston
danhuston.com
Dan Huston is an artist based in Brooklyn, New York. While studying studio art at Bates College in Maine, he spent a semester abroad at Gaidai University in Hirakata, Japan. This experience gave him the opportunity to immerse himself in Japanese art history and traditional ink painting.

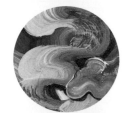

Evan Jones
evanjonesartist.com
Evan Jones is a painter and multidisciplinary artist from North Carolina. Evan received a BFA from Savannah College of Art and Design, and his work has been exhibited in New York, Los Angeles, and Georgia. He is currently based in Atlanta, Georgia.

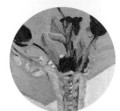

Dominic Joyce
dominicjoyce.co.uk
Dominic Joyce is an artist and designer whose paintings and interior and product designs are inspired by Pop art, fashion illustration, and graffiti-style street art. Joyce has a long-term exhibition at 1000 Lakeside North Harbour, Portsmouth. His works are available from his website, Saatchiart, and Society6. He lives and works in Hampshire, England.

Hannah Klaus Hunter
hannahklaushunterarts.com
Hannah is a botanical artist, living on Whidbey Island, WA, where the terrain, trees, plants, and leaves inspire her monoprint collages. Her work can be found in various public collections, including New York University, the University of California, Davis, and Kaiser Hospitals, as well as on her website.

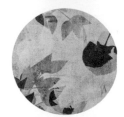

Lori Larusso
lorilarusso.com
Lori Larusso earned a master's in fine arts from the Maryland Institute College of Art, and is now based in Kentucky. Her paintings explore themes such as bourgeois domesticity and images of stereotypical middle America. Larusso's work has been exhibited internationally.

Jemma Lewis
jemmamarbling.com

Jemma Lewis Marbling & Design is a workshop and design studio based in Wiltshire, England, that produces a comprehensive range of hand-marbled papers, from their own designs right through to bespoke commissions for bookbinders, publishers, designers, and restorers.

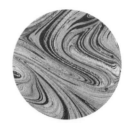

Sherry Loehr
sherryloehr.com

Sherry Loehr's inspiration comes from nature: fruit, flowers, leaves, and birds. Her still lifes and natural scenes often focus on a particular color note, texture, or the suggestion of a mood. Loehr's work has been featured in many publications, including *American Art Collector*, *Southwest Art*, and *Acrylic Artist Magazine*. She lives and works in Ojai, California.

Kathryn Macnaughton
kathrynmacnaughton.com

Born and now based in Toronto, Kathryn Macnaughton studied illustration at OCAD University, Toronto. Her abstract paintings are inspired by collage, vintage palettes, and digital illustration, and have been exhibited in the United Kingdom, Canada, and the United States. Macnaughton has worked with Bailey Nelson, Nordstrom, and the Gardiner Museum in Toronto.

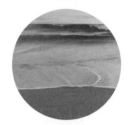

Marta Marcé
martamarce.com

Marta Marcé is a Catalonian-born, London/Berlin-based artist who obtained an MA from the Royal College of Art, London. Marcé sees painting as a language that reflects the human condition and our capacity to be inspired and to express life. As such, she imbues each of her artworks with an immense energy that's vibrant and full of humanity. Her work is exhibited internationally.

Mando Marie
seeyouthroughit.com

Mando Marie is an American-born artist currently living and working in Amsterdam and Portugal. She creates highly recognizable stencil-based imagery at both mural and gallery scale. Marie's rich, constantly expanding visual language focuses on children at the edge of adulthood and totemic characters set in painterly compositions. She uses the moniker "See You Through It" on the street and on the web.

Elise Morris
elisemorris.net

Elise Morris obtained a BA in painting and printmaking at the University of California, Santa Cruz. She seeks to explore nature's point of view in her work, capturing fleeting moments of growth and change. She has exhibited extensively and her work is held in corporate and private collections throughout the United States and internationally. She is based in Northern California.

Paul Norwood
paulnorwood.com

The Maine-born artist Paul Norwood received a BFA from Syracuse University, before establishing himself as an art director and creative director. He is now a full-time painter, and his work has been exhibited across the United States, from Boston to San Francisco. Norwood alternates between his studios on Martha's Vineyard and in Mill Valley, California.

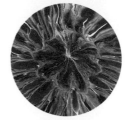

Jesús Perea
jesusperea.com

The Spanish artist Jesús Perea studied fine arts at the Universidad Complutense de Madrid, where he is still based. Perea's abstract creations reflect his interest in geometry, architecture, and simplicity, and allow him to explore the interaction between the rational and the unexpected. His work has been shown in Germany, Spain, the Netherlands, and the United Kingdom.

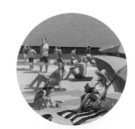

Annemarie Ridderhof
annemarieridderhof.nl

Annemarie Ridderhof is a fluid-art lover who shares amazing techniques and tips on her YouTube channel, which has over 130,000 subscribers, and her website. She is based in the Netherlands.

Glen Rubsamen
glenrubsamen.com

The LA-born artist Glen Rubsamen received his master's in fine arts at UCLA. Working primarily in acrylics, he seeks to document the city of Los Angeles, a landscape profoundly shaped by the human hand. In recent years his work has been shown in Munich, Strasbourg, Taipei, and Holland. He lives and works in both Los Angeles and Düsseldorf, Germany.

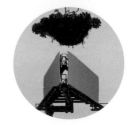

Lena Schmidt
lenaschmidt.com

Lena Schmidt studied fine art at the HFBK University of Fine Arts, Hamburg, and is currently studying communication design at HAW Hamburg Design Department. Schmidt's works have been exhibited in Germany, the United States, and the United Kingdom. She lives and works in Hamburg, Germany.

Ang Tsherin Sherpa
tsherinsherpa.com

Ang Tsherin Sherpa was born in Kathmandu, Nepal, where he studied traditional Tibetan thangka painting with his father, Master Urgen Dorke. Now based in California, Sherpa continues to explore tantric motifs, symbols, colors, and gestures, but within resolutely contemporary compositions, fusing the past with the present. His creations are shown regularly in Europe, Asia, and the United States.

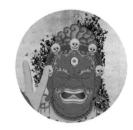

Jean Smith
jeansmithpainter.wordpress.com

Jean Smith is a Vancouver-based painter, writer, and singer. Her contemporary portraits, based on photographs, are about complex emotions related to feminism and anti-capitalism. She sells the 11 x 14" series for US$100 on Facebook, to make her work more accessible to others. Sales that exceed her monthly expenses go toward opening the Free Artist Residency for Progressive Social Change off the west coast of Canada.

Claire Tabouret
clairetabouret.com

The figurative painter and sculptor Claire Tabouret was born in Pertuis, France, and is now based in Los Angeles. In her work Tabouret seeks to explore childhood and its enigmas, along with the individual, whether isolated or within a group. She has held numerous solo exhibitions in Europe, China, and the United States.

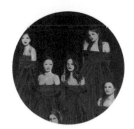

Sarah Winkler
sarahwinkler.com

The British-born artist Sarah Winkler studied art and earth science at William Paterson University, New Jersey, and combines both subjects in her artwork. Winkler now lives and works in Colorado, a landscape that frequently features in her large-scale desert and mountain paintings. Her work resides in many prominent private, public, and corporate collections and is represented through galleries and at major art fairs.

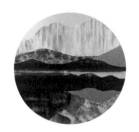

GLOSSARY

abstract art A visual language that attempts to communicate ideas and sensations through shape, line, form, and color, rather than by accurately portraying visual reality.

bleeding An artistic technique in which fluid color is allowed to spread and sink into the fibers of the surface.

brayer roller A rubber roller traditionally used in printing and printmaking.

Bristol board An uncoated, machine-finished paperboard that provides a stiff, strong surface. Bristol board is typically available in two finishes: smooth and vellum, which has a more textured surface.

clayboard A sturdy surface with a smooth, absorbent finish.

contact paper An adhesive paper used to form stencils or masks that will protect certain areas of a composition from paint.

cross-hatching A drawing technique in which fine parallel lines are drawn close together and overlaid with parallel lines running at an opposing angle. This technique is used to create the illusion of shade or texture.

drypoint needle A hard-pointed tool, traditionally used in printmaking, which can be used to scratch the paint's surface and reveal whatever color lies beneath. A drypoint needle is particularly useful for the sgraffito technique.

fan brush A thin, flat brush with curved bristles. Fan brushes are traditionally used to blend colors, but can also be used to make a variety of marks.

figurative art A form of modern art that clearly references objects and forms found in the real world.

filbert brush A highly versatile flat brush with an oval end. Filberts are well suited to blending, applying washes, and painting soft, rounded edges.

flat brush A brush that ends in a flat line. Flat brushes are great for painting areas of flat color and bold lines, and when using the impasto technique.

Gelli Plate A durable, reusable printing plate typically used with monoprinting. Gelli Plates look and feel like gelatine.

gesso A white paint mixture used to prepare a canvas for painting, by making it ready to accept paint—without it, the paint would simply soak into the canvas. Black and colored gessos are also available.

gold size An adhesive commonly used in the process of applying gold leaf to surfaces.

ground (see also primer) A term used to describe any surface on which you paint. This usually takes the form of a primer that has been applied to raw canvas or paper.

heavy-body acrylic A form of acrylic paint with a thick consistency that retains brush and knife marks well.

hue A term used to describe any color in the spectrum—red, blue, yellow, etc. In painting, however, "hue" is also used to name particular colors in order to indicate their color temperature.

impasto A painting technique in which thick layers of paint are applied to a canvas or board, to form highly textured areas that stand out from the surface.

marbling The process of floating pigments and dyes on top of a liquid, usually water, and then transferring them to paper. The marks and

patterns the inks make often resemble those found in marble and other types of stone.

medium A term that can describe any particular art form, such as sculpture or painting, and also describe which materials have been used to create an artwork, such as "paint on canvas." When working with acrylic, the term "medium" also refers to additives that, when mixed with paint, alter such qualities as texture, weight, and sheen.

negative space The area around or between objects in an image.

palette A thin board or slab on which a painter mixes pigments.

pigment A finely powdered substance that is added to inks and paints to give them color.

pounds The thickness of watercolor paper is indicated by weight, measured either in pounds per ream or grams per square meter (gsm).

primer A ground, or undercoat, that gives canvas and other surfaces enough absorbency and grip to receive paint and mediums, while also retaining a certain malleability and movement.

retarder A form of medium that increases the drying time of acrylic paint.

saturation A color's intensity.

sgraffito A decorative technique in which scratches are made in a surface to reveal a lower layer of a contrasting color.

shade A comparatively darker color created by mixing black paint into a lighter one.

shader brush A brush with angled hairs that is suitable for painting curved lines, blending, and filling in corners.

soft-body acrylic A form of acrylic paint with a creamy texture that levels evenly. Soft-body acrylic is less dense than heavy-body.

solution A mixture in which a solid or material has been dissolved.

solvent A substance that dissolves other liquids and materials, forming a solution.

tint A comparatively lighter color created by mixing white paint into a darker one.

value How light or dark a color is.

INDEX

Page numbers in *italics* indicate illustrations

PICTURE CREDITS

Unless otherwise stated, all images by Rita Isaac.

4 Arthur Brouthers (arthurbrouthers. com); 8–19 Ida Riveros; 27 Jean Smith; 28 Dominic Joyce; 31 Joanna Maria Dziedzianowicz with thanks to models Joanna Kanigowska and Julia Czamarska; 35 Sherry Loehr; 36 Photo by Sugitra Gantner. Courtesy of Alfonso Artiaco Gallery, Naples; 39 Elise Morris; 42 Daniel Huston; 45 Paul Norwood; 47 Dan Henderson; 49 Kathryn Macnaughton; 50 Marta Marcé (www. martamarce.com); 52 Clair Bremner; 63 Jesús Perea; 64 Claire Tabouret. Photo: © bluntbangs.bizs; 67 Hannah Klaus Hunter © 2016; 73 Mando Marie; 77 Yann Chatelin; 79 Mary Arkless;

83 Painting by Evan Jones. Instagram @townhouseonmars, website: evanjonesartist.com; 85 Lena Schmidt; 86 Oliver Dorfer; 89 Charly Baxter; 90 Sarah Hardy-Box; 93 Sarah Winkler; 95 Shannon Finley; 97 From the collection of Stephen Bolton and James Magruder. Image courtesy of the artist; 99 Courtesy of the artist and Rossi & Rossi Gallery; 100 Leah Bartholomew for Petite Interior Co., photograph by Vellum Studios; 104–5 *Personal Universe* (Chroma Show Series, 2017) by Arthur Brouthers; 106 Annemarie Ridderhof; 108 Courtesy of the artist and Waddington Custot Gallery. Photo by Todd White; 110–13 Annemarie Ridderhof; 115 Jemma Lewis Marbling & Design, www.jemmamarbling.com.

ACKNOWLEDGMENTS

A big thank you to everyone who put so much time and effort into bringing this book together, particularly the artists who shared their work and insights. On a personal but still acknowledgment-worthy note, I'd like to thank everyone who encouraged me to accept this challenge and supported me through it, especially my mother, who left me the only legacy I aim to honor, her example; my father, who could not have been more supportive, even without knowing it; and my people, Susana Wessling and Maria Ferreira, without whom no word would ever make sense.

ABOUT THE AUTHOR

Rita Isaac is a Portuguese inter-media artist, currently living and working in London. She studied painting, and her artistic practice has evolved to incorporate a wide variety of painting materials and techniques. Isaac has been sharing these skills in workshops and training sessions across the United Kingdom for a number of years, and her work has been exhibited internationally.